Hauntings of the
Hudson River Valley

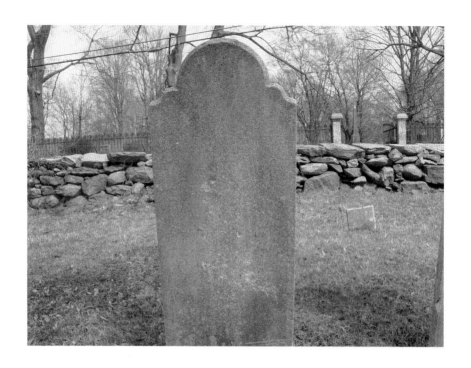

Hauntings of the
Hudson River Valley
An Investigative Journey

Vincent T. Dacquino

Published by Haunted America
A Division of The History Press
Charleston, SC 29403
www.historypress.net

Cover image: Statue of Sybil Ludington at Lake Gleneida. *Courtesy of Putnam County Historian's Office.*

First published 2007
Second printing 2009
Third printing 2010
Fourth printing 2011
Fifth printing 2012

Manufactured in the United States

ISBN 978.1.59629.242.0

Library of Congress Cataloging-in-Publication Data
Dacquino, V. T. (Vincent T.).
Hauntings of the Hudson River valley : an investigative journey / V.T. Dacquino.
p. cm.
Includes bibliographical references.
ISBN-13: 978-1-59629-242-0 (alk. paper)
1. Ghosts--Hudson River Valley (N.Y. and N.J.) 2. Haunted places--Hudson River Valley
(N.Y. and N.J.) I. Title.
BF1472.U6D33 2007
133.109747'3--dc22
2007029679

Contents

The Hanging of George Denny

INTRODUCTION

On the thirteenth day of November, in 1843, eighteen-year-old George Denny was indicted for brutally shotgunning a beloved eighty-year-old resident of Philipstown, New York. According to court records, Denny lured Abraham Wanzer outside of his cabin around ten o'clock at night and shot the octogenarian in cold blood. Denny was taken into custody and tried twice in the same county courthouse. He was sentenced to hang. On the day before the hanging, wagons began to roll into town. Four thousand people came to watch.

INVESTIGATION AT THE INN

On one of my visits to the Smalley Inn to investigate reported ghost sightings, I sat with Anthony Porto Sr., the innkeeper and proprietor of the popular Carmel eatery.

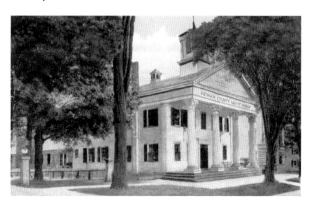

Postcard of Putnam County Courthouse. *Courtesy of Betty Behr.*

"My name is Vin Dacquino. I'm a history investigator and writer," I said, and pulled out a copy of *Sybil Ludington: The Call to Arms*.

"Oh, you're here about the ghosts?"

I smiled and tried not to seem overly excited. I had heard about the ghosts more than once. My own daughter came running into the house one night with a picture she had taken there. We passed it around the kitchen and were all convinced that something was in the picture that shouldn't have been there.

"I hear there are rumors about ghosts in your restaurant," I said.

"Oh, they're more than rumors. Did you see any of the articles in the papers? K104 radio station did a whole radio show segment on us. Did you see the chapter in Linda Zimmerman's book?"

"Linda Zimmerman?"

"The paranormal," he said. "She was here with all of her equipment and everything. You aren't a ghost hunter, right?"

"No," I said. "I'm more of a history investigator. Do you know who any of these ghosts are? Maybe I can find out why they are haunting you."

"I already know who some of them are and I know why they come here. It's in Linda's book, but I can tell you the whole story if you want to know."

His story was amazing. It covered everything from teen suicide to real gravestones being used as Halloween decorations. When he started talking about "the guy who was hanged across the street here," I sat up straighter. I had heard of the hanging of George Denny, but knew few of the details.

"This one group," he said, "comes in here with their equipment. You know, cameras and recorders, and the last time they were here, they could hear the rope creaking."

"Do you think it was George Denny's ghost?"

"I don't know. You could talk to them about it. They're coming again on Thursday night."

On Thursday night I was sitting at the bar waiting patiently. I had a beer to relax and checked my watch. It was twenty minutes past seven o'clock. They had been due at seven. I considered getting a second beer, but I wanted to be sure that any spirits I was going to see were not coming from my glass. At 7:30, I asked the barkeep if Anthony was coming in and she said she didn't think so. I told her that I was waiting for someone he said would be here. She called him on his cell phone. He told her plans had been changed; the paranormal would be there with her team at ten o'clock on Saturday morning instead. I was invited to come if I wanted to. The restaurant would be closed and I could enter with them through the back door.

I went home disappointed. On Saturday, I slipped into jeans, grabbed a tape recorder and notebook and went to the restaurant, not expecting to meet anyone there.

I pulled up in the back parking lot at about 9:50 a.m. Four people were unloading a station wagon and I parked several spaces away from them. Behind the car, a man with a white plastic bag was standing away from the group and I moseyed on over to him.

"Hi, I'm Vinny Dacquino," I said.

"Buddy Banks," the man answered. He shook my hand but didn't say anything about why he was there. The name Buddy Banks rang a bell with me. One of the historians had said, "There is a guy you should look up. He is a psychic photographer and he goes on some of the investigations. He's a little eccentric and likes to work alone, but you'll want him with you when you go on investigations. His name is Buddy Banks."

The four people from the car unloaded more boxes and recorders and began loading things under their arms and onto their shoulders. I walked over to a woman who appeared to be the team leader.

"Hi, I'm Vinny Dacquino," I said. "Tony mentioned that you were going to be here this morning. I'm working on a book called *Hauntings of the Hudson River Valley*. Do you mind if I sort of tag along during your investigation?" I handed her one of my cards. She reached into her pocket and handed me one of her cards while she spoke.

"Hi, Vin. I'm Kathy," she said. "No problem." She looked up at the stairway leading from the parking lot to the back door of the restaurant. "I think we can go in now."

After a lot of getting ready and plugging in of equipment, they started chatting; I introduced myself to the team members who had just entered. They had no problem with my asking for their names and contact numbers. My tape recorder was plugged into the wall because I had been forewarned that ghosts zap energy. I didn't want my batteries dying in the middle of this investigation.

Business card for the Katonah Paranormal Research and Investigation Team.

Katonah Paranormal
Research & Investigation Team
Kathy O'Donnell Piccorelli
Founder & Team Leader
Grnrapture@aol.com
914-232-9439

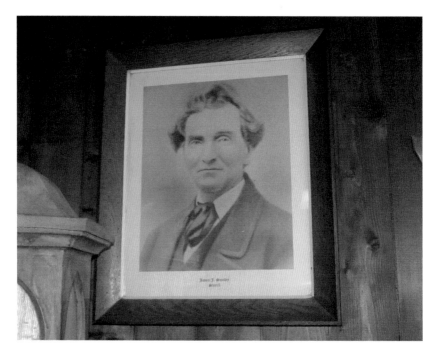

Portrait of James J. Smalley. *Courtesy of the author.*

Kathy was talking with several team members and explaining that the Smalley Inn basement was divided into two separate parts, each with a staircase of its own. The front part was a sort of party room being prepared for remodeling. The rear portion was where most of the ghost sightings had been. It contained a meat locker, a workbench, some storage space and a liquor room.

Before long, I was in the rear portion of the basement with a small group of investigators. The lights were off and we were standing in front of the walk-in liquor closet. The rumor was that this room had been used at one time by James J. Smalley in the 1800s. James ran the Smalley Hotel and served as part-time county coroner. This room was his supposed morgue. A short biography of James J. Smalley is printed on the placemats at each table. A large portrait of him hangs in the main dining room by the haunted mirror.

I was busy trying to breathe when I heard Buddy talking into the liquor closet. "Are you down here? We've come to visit with you. Can you give us a sign that you're here?"

A light went on in the liquor room and several of us gasped.

"Thank you," Buddy said. "Can you turn it off for us now?"

The light went off again, and I felt a chill go through me.

Smalley's Inn
Since 1852

James J. Smalley

James J. Smalley was born in the town of Phillipstown, in 1813, where his parents, John and Elizabeth Smalley, spent their entire lives and reared their 4 sons. The educational advantages afforded Smalley were those of the public schools near his home, so he began life on his own account as a day laborer, building many of the stone walls in his native county. Later he owned a small place at Farmers Mills and in 1852 purchased the hotel at Carmel which he greatly improved, renamed and successfully conducted as the Smalley Hotel until his death in 1867.

His native American spirit and great energy enabled him to rise from a lowly position in life to one of affluence, for he was truly a self made man, his life illustrates in no uncertain manner what is possible to accomplish when perseverance and determination form the keynote of a man's character. Smalley was a recognized leader of the Democratic Party in P.C., serving first as coroner. For 2 terms he was an efficient sheriff of the county and was serving his 3rd term as county treasurer at the time of his death.

In 1849, he was elected a member of the Assembly and was reelected to the post in 1854. While a member of that body he was associated with Saxon Smith of P.C. and A.J. Coffin of Dutchess County. He also became a staunch friend of Hamilton Fish, former governor of NY and Sec. of State under General Grant. He died at the age of 54 in 1867.

Smalley's menu. *Courtesy of Anthony Porto Sr.*

"Does anyone know of any of the ghosts' names?" Buddy asked.

I wasn't sure if he was talking to us, or them, so I kept quiet. A voice sprang up from behind me.

"I think there's a little girl named Elizabeth down here," a woman said.

"Elizabeth? Are you here?" Buddy asked. "Will you manifest for us? Turn the light on if you hear me."

The light did not go on.

"Does anyone know anymore names?"

The woman next to me said, "Try calling for George. I keep hearing the name George, George, George."

The wind went out of me.

I took a long deep breath as I heard Buddy say, "George, if you are here, turn the light on."

The light went on.

A man to my left said, "This is so cool. I checked the switch in the liquor room before. It's in the off position."

Then I heard someone say, "George? George Denny, I am writing your story to set the record straight. Will you help me?" My blood suddenly ran cold as I realized that I was the one who had said it.

I felt myself walking toward the liquor room and as I tried to enter, it was nearly impossible. I was freezing and had trouble catching my breath.

I spent the next few minutes trying to regain my composure, and when I was ready to confront whatever was in there, there was nothing to confront. The session was over. Lights went on and the group began talking loudly. I turned to them confused and then looked back into the liquor room. Bottles were on shelves and it looked like an ordinary storeroom. I followed reluctantly as the group turned to go upstairs where photos were being taken everywhere. I stayed with them, not really listening; I had to go back downstairs. Nervous, but not frightened, I walked to the basement door and descended the stairs alone, prepared to talk to George. The lights were on and I walked slowly toward the small room. The aura was gone. I had no goose bumps and the temperature was fine. George had apparently gone off somewhere.

INVESTIGATING THE SOURCES

My investigation of the Wanzer murder began at the county historian's office in Brewster, New York. I explained what I was looking for and was disappointed when Christina Mucciolo, one of the researchers, handed me a very thin file marked "George Denny." I browsed through the sheets. There were several photocopies of typed materials paper-clipped into groups. There was also a long handwritten poem with no author or information given. One set of handwritten notes contained partial transcripts of the Denny trial. A second set of papers appeared to be some sort of notes and a manuscript for a newspaper article written years ago, but no copy of the actual article. I studied the notes. The following excerpt, copied from a corrected proof found among Denny's papers, is printed as found with typing and spelling errors, and is here reprinted by permission of Putnam County Historian's Office.

Notes on a Hanging

Hanging of George Denny by Willitt C. Jewell.

Nearly a century ago, on the 26th day of July, to be exact, George Denny, a boy of 18 years of age, and a native of the town of Philipstown was executed in the yard at the rear of the county jail and courthouse in Carmel village, by hanging. He shot and killed Abraham Wanzer, an old man of 80 years who lived in a cabin on the Carmel–Cold Spring road near the western end of the Cold Spring woods. Denny was tried

twice for the murder, found guilty at the second trial and sentenced to pay the death penalty for his deed. He was hung and his body taken to Cold Spring for burial.

Denny was the first person to be convicted of a murder in Putnam county after Putnam became a county in 1812 and was the only murderer ever executed in Putnam county during its 111 years of history from the date of its formation to the present time.

During all these years it is singular that only one other person was convicted of murder first degree. He was Samuel Haines, a negro, of Patterson and he paid the death penalty in the electric chair at Sing Sing on July 30, 1915.

So unusual were the circumstances of Denny's execution, marked as they were by a public parade, the holding of his funeral while he sat on his coffin preceding the hanging, the assemblage of hundreds of people from all parts of the county, and the veritable declaration of a local holiday, that the facts as gathered are presented here so that they may not be lost to future generations.

Location of Wanzer's Gardens. In order that people may gain an idea of the locality of Wanzer's home in 1843 the following brief description of the country is given:

Wanzer lived in a small log cabin in the highlands of the Hudson and near the western end of what is today called the Cold Spring woods. Through these woods today runs the county road, sometimes known as the Cold Spring turnpike. This road winds its way for seven miles through a continuous wooded section, over the mountain and through valleys and is an ideal drive during the summer and fall seasons. This picturesque country road meets the Albany Post Road at McKeels corners about 3 miles east of Cold Spring. Going east on this turnpike road from McKeels Corners about 1 mile is a concrete bridge and a short distance further on is a second concrete bridge. About midway between these 2 bridges is a road which turns to the left, if one is going east, and a short way up this road was located Wanzer's Gardens. This place is now owned by Chester Smith and the foundation of the old cabin can be seen to this day.

According to the information gathered from various residents regarding the hanging the following account has been prepared:

Preparing The Gallows
Execution of a boy for murder, by hanging, which was to mark the first official use of gallows in Putnam county, was to be an act that attracted the attention of people from all sections and it was evident that the people

planned to have the execution serve as a warning to all of the present and future generations of the dreadful end which awaited all human beings who should be found guilty of this crime - murder in the first degree.

Execution of the man made necessary the construction of gallows in Putnam County and the work was started soon after Denny was sentenced.

For many days previous to the execution, the authorities were busy preparing the gallows paraphernalia for use and families about the countryside were making arrangements to visit the county seat in the hope of witnessing the hanging scheduled to be done on July 26, 1844 between five o'clock in the morning and seven o'clock in the afternoon.

Crowd Gathers at Carmel

Quite a number of men arrived on the evening previous and gathered about the court house. Agricultural pursuits and all other matters were forgotten while the chief topic of conversation was the execution of Denny, who had but a few more hours to spend on earth. They inspected the gallows and not taking a chance on missing any feature of the program planned, did not go to bed but remained about the court house all night. The silence of the night was occasionally broken by the rumbling of a wagon and voices of men and women who had finally reached the village from some neighboring hamlet. Throughout the early morning hours people continued to congregate until at last when the hour had arrived for the execution there was a large assemblage of people.

Denny was confined in the small stone jail which was located a short distance back from the sidewalk. The jail was a one story stone structure about 12 x 20 feet. The entrance faced the street and there were a few small openings to provide light. The floor was of stone and during the winter a wood stove furnished heat. Fuel was provided by the jailor and the prisoner or prisoners confined took charge of the fire. It was said that Denny was the sole inmate of the jail at the time.

Planned to Kill Undersheriff and Then Escape

Jesse Baker was jailor at the time, James Smith was sheriff and William Taylor, under-sheriff. None of these officers resided at the court house which at that time was used for offices. Denny was especially fond of Sheriff Smith, but had no admiration for either Under-Sheriff Taylor or Jailor Baker. During his lonesome hours as sole inmate of the jail he planned to kill Taylor and also had arrangement nearly completed to escape from jail through an underground tunnel, when his plans were discovered by Baker.

The ash pan in the stove of the jail had an iron rod around its top. Denny removed this rod and by rubbing it on the stone floor had made a spear-like point on it. With this weapon he planned to kill Taylor on his next visit to the jail. He had also worked loose a few stones in the floor and had an underground tunnel partly prepared through which he planned to escape. Jailor Baker discovered his plans and shackles were placed on his legs and these chained to the floor so that his plans to kill Taylor and escape were not carried out.

The shackles and chain were kept by Baker and passed on to his son, Lewis Baker. They were exhibited at the county fair some years ago but the location of the outfit is not known at the present time.

Denny's meals were prepared at Jailor Baker's house in the village; now the home of Alanson Arnold and carried to the jail by Baker.

Had Many Visitors

During the time Denny was confined in the jail, many people visited him, including Mrs. Sarah Dykeman and Miss Nancy Travis. A revival had been in progress in the village during the winter and Mrs. Dykeman, who was an interested religious worker, asked Denny if he had ever repented for his deed. Denny related to her how when a small boy the first thing he took was a drawing of tea from a store in Cold Spring. He resided with his grandmother and taking the tea to her, she inquired where he got it. He explained and she told him to get some more if he could.

Many people passing by the jail would stop and talk to Denny during the season when the weather was warm and it was necessary to keep only the iron gate closed.

The present portico and pillar had been erected at the front of the court house in 1840 and the present porch was the one on which a part of the ceremonies took place.

Execution Day Arrives

When the time arrived for the beginning of the tragic event, Denny, under guard of the officers, was brought from his cell. As the youthful lad of 18 years stepped out on the porch, all eyes were focused on him, necks were stretched to their limits and elevated locations were at a premium. Many a sigh was heard from women who were in attendance while it was said some nearly fainted.

The ceremonies, which began in the morning, according to the information gathered, continued until late in the afternoon being concluded with the hanging.

Denny Parades with Rope About His Neck
Shortly after Denny reached the porch, the rope with which he was to be hung, was produced, being easily distinguished by the noose at one end. The old residents state that the noose was placed about his neck, the sheriff or deputy holding the other end and accompanied by the crowd of onlookers, he paraded down the village street some distance and back to the court house porch.

Funeral Service Held
Next in order came the holding of the funeral service. From a secluded spot in the courthouse was brought Denny's coffin, an old-fashioned hexagon shaped affair. This was placed on the porch and Denny, with the noose about his neck, sat down on it. John Sloat, a local Methodist preacher, one of the three preachers who were on this circuit at the time took his place on the porch and conducted the service preaching an extended funeral sermon. It was said that several hymns were also sung.

Taken to the Gallows
At the conclusion of this service, Denny was taken to the court yard at the rear of the court house and inside of the high fence where the gallows were located. Certain officials, lawyers, doctors and a few others were admitted inside the fence to witness the execution. The crowd of people flocked to the rear also and those who were able to climb up in nearby trees while others not endowed with the buoyancy of youth took advantage of the cracks between the boards of the fence in an effort to witness the hanging. A few, who did not care to see the tragic end, remained in front but eagerly listened for the sound of the creaking of the wood work of the gallows.

Sheriff Smith became quite attached to Denny during his stay in jail and some weeks previous to the day set for the hanging, said he could not execute the boy and having authority to deputize the undersheriff informed Taylor he would have to perform the execution. Taylor replied," Don't worry, it won't be any trouble for me to hang him."

When the time for the execution did arrive Under-sheriff Taylor proved to be a man of his word and carried out the hanging without difficulty, thus ending the life of Putnam's first murderer.

Many Faint at Hanging
When the rope was cut and the body of the boy went up, several of the men and women present fainted, being overcome by this gruesome sight.

This was attributed in part to weakness on the part of the men, who had spent the night there without sleep and the long fasting since leaving their homes the day previous.

Denny's body was examined by the doctors and when pronounced dead, it was placed in his coffin and the cover nailed down.

Relatives Take the Body
Denny's relatives, most of whom lived in a community in Philipstown, came over to the execution in a big wagon. It contained only the driver's seat, and the members of the family sat in the wagon body.

After the execution in preparation of Denny's body for removal, the coffin was placed in the Denny wagon, the relatives sat down on it and they proceeded out West street on their return to their homes in Denny town, where Denny's body was buried in a cemetery.

People around the courthouse watched the wagon until it passed out of sight over the knoll of Raymond Hill, expressions of sympathy for the bereaved relatives being heard in every direction.

The Lesson Taught
With the concluding of the execution, people returned to their homes. Those coming from neighboring places gathered their families together and wagon loads could be seen leaving the village over almost every road that branched out in the various directions. A great day in Putnam county, long to be remembered, was fast passing into eternity as the sun set behind the hills, but an impression had been made on the minds of the people which was lasting, the terrible consequence which was to come to those who go astray had been demonstrated and was to provide a lesson and warning to those surviving and to generations yet to be born.
When the various people reached their homes, some arriving in the moonlight, neighbors flocked about them eagerly waiting to hear the story of the execution of Denny. One eye witness when asked if they hung him, replied, "Yes, they jerked him from hell to breakfast."

Rev. John Sloat, who preached the funeral service, returned to the home of James Foshay, in Kent, where he was overcome by the effect of the day's proceedings and suffered a nervous breakdown being confined to his bed for several days and remaining there a week, before he was able to resume his duties as preacher on the circuit.

For weeks and months the execution was a topic of conversation in many households of the county and the story was related by parents to their children in later years, and the few children of those days who

now survive comprise the oldest generation of the present day. Many of them of three score and ten and a few who are between 80 and 90, recall very vividly the story of the execution as related to them by their parents who were eye witnesses and from these sources which we believe to be thoroughly authentic the forgoing account of the execution, which concluded here was obtained.

The "article" ended here. The second set of papers was a transcript from the trials. I attempted to read them in the office but they were second-generation photocopies and difficult to read. I pulled out an unused manila folder, marked it "George Denny Chapter" and continued with my investigation.

BENJAMIN BAILEY

My next stop was at the Reed Library, in Carmel, where I checked through some of my old reliable Putnam County resources. Little about the trial was included in William Pelletreau's *History of Putnam County, N.Y.*, but the book did offer some good information on Benjamin Bailey, Denny's lawyer. It should be noted that in most written instances, "Bailey" is spelled with the "e," but Benjamin Bailey himself spelled it "Baily."

BACK TO THE RESEARCH

Setting aside Pelletreau's book, I reached for William Blake's *The History of Putnam County, N.Y.* This was the jackpot. Blake not only printed the

Benjamin Bailey, son of Benjamin Bailey, was born in Carmel in 1813. He was admitted into the Bar 1842 and immediately thereafter commenced the practice of law in Carmel, where he remained until the year 1853.

As a lawyer he was often called to the defense in criminal cases. The most noted case in which he was engaged was that of George Denny, who was tried for the murder of Abraham Wanzer, in 1843. Denny was tried twice, the jury failing to agree upon the first trial, but upon the second he was found guilty and afterward executed. Mr. Bailey tried the case for the defendant upon both occasions and was indefatigable in his efforts to save him.

From Pelletreau's History of Putnam County

Note: Bailey had been a practicing lawyer for about one year when he was assigned to this murder case. He was thirty years old

transcripts of the trial, but also printed Denny's full confession to Benjamin Bailey.

I read the transcripts of the trial carefully. The transcripts Blake used were obviously the same, in part, as the copies from the historian's office, but my files had included nothing about a confession. Why was this confession not in the court records? Where could I find the original?

I went to another reliable source—Lillian Eberhardt, president of the Town of Carmel Historical Society—who was eager to help. She told me to get a copy of *Southeastern New York: A History of the Counties of Ulster, Dutchess, Orange, Rockland and Putnam: Volume II*. She said part of it was written by the man I had mentioned, Willitt C. Jewell. The section I wanted was titled "Murders in the County." I read through it eagerly. It briefly summed up the story of George Denny's case, but was clearly not based on the prepared notes in the historian's office.

Lillian called me back a few days later and said that I should see the file she had found on Denny. Among Denny's files there was a narrative poem written in 1844, but photocopied more clearly than the earlier copy I had seen. I shuffled through the papers feverishly. There was no indication of the author of the poem other than the initials "J.S.C."

The heading on the notes Lillian gave me read: "On the Murder of Ab'm *Wanser of Phillipstown, Putnam county and the Execution of George Denny, by J.S.C. of Carmel 1844." I searched carefully for clues—and found them.

There was a set of the same notes that had been in the historian's office. These were also much clearer and easier to read and came with an additional set of handwritten notes from the author. One set appeared to be a sort of outline for the continuation of the article he was writing.

HUNG AT COURT HOUSE IN CARMEL

George Denny, an 18 year old boy convicted of the murder of Abraham Wanzer, 80 years old, in the cold spring woods in 1843, was hung at the rear of the court house in Carmel in 1844. He was the only murderer executed in Putnam county.

Denny sat on his coffin on the Court house porch while his funeral service was held before he hung.

The account of this occurrence is an important part of the History of Putnam County.

THE STORY OF THE
TRIALS, CONFESSION AND EXECUTION OF GEORGE
DENNY
Will be published in
The Putnam County Courier
Friday Afternoon; 1923
Order Your Copy Now.
Page 2
Court Minutes of Denny's Two Trials
The official court minutes of the first and second trials of Denny, written in long hand are on file in the county clerk's office here. They appear in a book, which a few years ago was rebound in red leather and today has every outward appearance of being a new book. On this book in gold letters appears the following:
County Court
Oyer and Terminer
Election Returns
A Putnam County
 The minutes of both trials as they appear in this book follows:
First Trial

Second Trial
Trial and Confession of George Denny
Benjamin Bailey, who defended George Denny, secured a full confession from him just prior to his execution and in 1844 prepared an account of the trial. This account together with the confession of Denny was published in pamphlet form in 1844. It comprised 16 pages. On the cover appeared the following:

Confession
Of
George Denney:
Convicted of the
Murder
Of Abraham Wanzer
At the May Term of the Putnam Oyer and Terminer, and sentenced to be executed on the 26th day of July next, made in presence of Benj. Bailey, Esq. his counsel.
Together with
A Brief Sketch of his Trial

Denny's Execution a Part of Putnam's History; Prepared From Facts Given By Old Residents

THE story of the trial and execution of George Denny, the 18 year old boy who shot Abraham Wanzer in 1843 and who was the first person convicted of first degree murder in Putnam county and the only murderer ever executed in Putnam county, forms an important part of the history of our county.

Diligent search and inquiry by the writer has failed to reveal any record of this case with the exception of the court minutes of the trial and the small booklet containing an account of the trial and Denny's full confession written in 1844 by Benjamin Bailey, who was the attorney who defended Denny at his trials. These booklets have become almost obsolete during the years that have passed and after endeavoring for many months to locate one of these books during which time hundreds of people were interviewed, one copy has been found. It is the property of Mrs. Edmund D. Foshay, of Kent Cliffs, to whom we are indebted for its use.

This little booklet, bound with a rough brown paper cover which has become brittle with age, does not contain any account of the execution of Denny, the story of which is a hair-raising, awe-inspiring episode that would appear ghostly and not be tolerated in a civilized community during the present generation. Nowhere has it been possible to find any written or printed account of the execution, but facts regarding this unusual event which occurred at the court house in Carmel 79 years ago have been gathered from several old residents who have corroborated each other in their stories even to details and the account which appears here is based upon the facts obtained from them and is believed to be the only account of this execution and is published so that it may not be lost to this and future generations. It has been prepared after carefully reviewing the facts obtained and is believed to be accurate. With that hope it is presented to the public.

From the April 20, 1923 *Putnam County Courier. Courtesy Putnam County Historian's Office.*

A print from a drawing, depicting Wanzer's cottage, Wanzer in the yard and Denny in the roadway with gun resting on the top of a fence rail, firing the fatal shot, is also printed on this page and beneath it these words: New York: Horel and Macay Printers, 89 Nassau, 138 Fulton St.

The notes not only contained the date of the proposed article, they even had suggestions for the size of type to be used. The second set of notes contained research notes. The first page of these later appeared in the newspaper.

DISCOVERING THE "JEWELLS"

I ran to the phone and called the historian's office. Cathy Wargas connected me to Christina Mucciolo, who searched through the old newspapers in the archives. The article from 1923 by Willitt C. Jewell was there in full. She said I could come for photocopies of the article whenever I was ready.

The next day I sat breathless with the article in front me. The handwritten notes from the historical society were found almost word-for-word in the article, and the outline of the second half of the article was completely fleshed out.

THE POEM BY "J.S.C."

It was all there. The poem was boxed off as a sidebar and is printed here as it appeared. This time "J.S.C." was replaced by the name Joshua S. Crawford. It began with Jewell's handwritten notes about the poem's author:

> *Lines of poetry on the murder of Wanzer and the execution of Denny were written in 1844 and became so popular that many people of that day memorized them and were so impressed at the time that many of the oldest generation of the present can now* [1923] *recite them.*
>
> *Joshua S. Crawford of Carmel was given credit for writing the verses, but some people claim that Charles Dunesbury, an essence peddler in the locality, who possessed a gift of reciting poetry as he made it up on occasion, was the author.*

On the Murder of Ab'm *Wanser of Phillipstown, Putnam county and the Execution of George Denny, by J. S. C. of Carmel 1844

> *Come old and young and middle aged*
> *Lest solemn thoughts your hearts engage;*
> *And from example warning take*
> *Before some dreadful end you make.*
>
> *Poor *Wanser, to his humble cot—*
> *Not dreaming what must be his lot—*
> *Returns from toiling in the field*
> *To take that rest retirement yields.*

To rest when weary! Oh, how sweet,
Around the home fireside to meet
The social circle in his cell
With thanks to God that all is well.

But soon the peaceful scene is o're
And death is lurking at the door;
For Satan finds some mischief still,
For those led captive at his will.

As from the door poor Wanser came,
George Denny points with deadly aim;
His gun discharged, his victim dies,
And fearful groans ascend the skies.

Two witnesses while Wanser bleeds,
Tell George the blackness of the deed;
He hears both God and Conscience tell
We saw you George, when Wanser fell.

Although in darkness, hid from sight
He to the mountain makes his flight
Yet conscience follows, crying still.
"Oh, why did you poor Wanser kill?"

In sad amaze at what was done,
Still haunted with that dying groan,
He cries, with anguish quite forlorn,
"Oh why was I, George Denny, born!"

In fear of men condemned of God,—
Still urged to further scenes of blood,
By Satan told to "burn and kill,"
And leave no one his deeds to tell.

But of this truth there is no doubt,
"The sinner's sins will find him out;"
All Satan's council proves a lie,
Condemned for murder, George must die.

His full confessions of his deeds,
Should make the hearts of parents bleed;
Poor lonely youth, gone far astray
With no kind friend to guide his way.

Thus left, from sin to sin he ran
No fear of God, no care for man,
Until the gallows end his race,
But death affords no hiding place.

Let each of us who read his fall,
Remember, we are sinners all.
God says to him, to you and I,
"The soul that sins shall surely die."

No soul in Heaven can find a place
Who slights the day and means of grace;
Poor George is gone, I give you charge
Mourn for yourself, and not for George

His sinful course is written here,
And yours may there much worse appear,
Unless you seek the sinner's friend
Your mourning day will never end.

That awful day is just at hand,
When all before the Judge must stand.
To reap the fruits of what they sow
In endless joy or endless woe.

*Note: Wanser spelled with an s

The entire confession was also printed in the 1923 article as it appeared in Blake's *The History of Putnam County, N.Y.* with a preface by Benjamin Bailey. It appears here as follows: (Note the lack of indentions for most paragraphs.)

Confession of George Denny

To the Hon. Amasa J. Parker,

Dear Sir:—A few days after the sentence of the above named most singular and unfortunate individual; I had an interview with him. I found him engaged in reading his Bible. Having said that I was pleased to see him endeavoring to prepare for the awful doom which awaited him, and from which I presumed there was not the most distant hope of escaping, I requested him as one who had taken a strong interest in his favor up to the time of his conviction, and who desired to lend his best

Article in the April 20, 1923 *Putnam County Courier. Courtesy Putnam County Historian's Office.*

efforts towards ensuring him peace in his last moments, to frankly and fully give me the history of himself, and especially of his participation in the crime of which he stood convicted. As I anticipated he declined. After conversing with him somewhat further, he requested me to explain the meaning of the 22nd verse of the 14th chapter of Romans. I gave it as my opinion that the passage to which he referred me was no obstacle to a confession, and if he desired to place himself in a position to understand what he read, it would be necessary for him to free his mind of the heavy burden, which I had every reason to believe was resting upon it, by giving a full and perfect statement of the whole transaction. He at length consented, and gave it as follows:

I am about 18 years of age; I was born in Putnam county. My mother died when I was an infant, as I am informed, insane. My father abandoned his wife and children a short time before my birth, unprovided for and unprotected. When I arrived to the age of eight years he returned and took with him my sister and myself to the State of Michigan, where

we remained about one year, during which time he was convicted and sentenced to prison for two years, for robbing a store. He made his escape by digging under the walls and returned to his suffering children. Within a few days he was retaken and imprisoned. My sister about fourteen and myself about eight years of age, without friends or necessary means, after many hardships returned to my Grandfather's in this county. That sister, from my infancy up to this moment has been my warmest and I can almost say my only friend, she has often given me good advice, and it is my earnest prayer that she may yet be rewarded. Here I would say to parents, and to all who have the charge of children, cultivate in them habits of industry and honesty, as I have every reason to believe if my mind had been turned into the proper channel in my infancy I should not be where I am. Two or three years after our return from Michigan, my father visited us and remained about one month. His mind appeared to have undergone a sad change since we had last seen him. He published a pamphlet founded on Revelations, in which he represented himself as Jesus Christ. I recollect of his saying to my Grandfather one day, that Buffalo was the Promised Land—that he should assemble all the people there, and amongst the number the Queen of England. I stepped up and told him he was a damned fool. He became very much enraged and pursued me out of the meadow, but I got out of his reach. The first inquiry he made of me was, "George are you old enough to handle the sword." He left, and we have never heard from him since.

Tells of Petty Thefts
During the time I lived with my Grandfather I had opportunity to attend school, but having the privilege of doing as I pleased I seldom attended— my attendance at church came under the above rule. My Grandmother indulged me in every evil habit and my education in consequence is very limited. I can make out to read by spelling some of the words but cannot write. When I pilfered money from my grandfather, which was not unusual, I was sure to find protection by appealing to my Grandmother. With the boys of the neighbourhood I bore the appellation of "the cunning little thief," and many times have I been reproached and called a fool by some of my relatives for acknowledging my thefts, which was usually the case if I was accused. With the exception of some trifles, and the money I took from my Grandfather and Mr. Wanzer's key, the first I ever stole was $4.75 from Andrew Miller's trunk, which I opened with Mr. Wanzer's key. I went on from one petty theft to another until I was compelled to leave my Grandfather's for fear of arrest, when I found my way to Shanandoah in the town of Fishkill. I remained there for a better part of a year

sleeping in the barns, woods, and coal cabins of the neighbourhood, until I was arrested in connection with Richard LaForce for stealing honey and confined in Poughkeepsie gaol. In justice to Richard Laforce I will take the first opportunity to state that he told the truth in his testimony, and that he was not concerned with me in taking the honey. After my discharge from Poughkeepsie gaol I returned to Shanandoah.

Shooting of Wanzer and Denny's Arrest
On Monday morning, the ninth day of October, 1843, I took Mr. Knapp's gun, dog and ammunition, with five or six balls from the same mould produced on my trial, which I had before secured, and went into the woods with the intention of shooting partridges. When I left Mr. Knapp's I did not think of Mr. Wanzer, nor had any intention of going there. I strolled through the woods on that day until I reached the Cold Spring Turnpike, passing by Henry Concklin's on my way down, but they did not observe me. I shot at the stump I showed Esq. Davenport with both barrels of my gun on Monday. I followed the Turnpike until I reached Thomas Jaycox's. My thoughts at this time were very singular and I suppose to many incredible, a partial description of which I will give in another place. I went to Benjamin Foreman's barn a little after dark and slept there till, as I should judge, about eleven o'clock at night. There was something laying heavy on my mind. I wanted to do something, I could not tell what. I almost unconsciously left the barn, took a road leading to Isaac Jaycox's, and thence the road leading to Mr. Wanzer's. I went to his door and made a noise—took hold of the string and raised the latch. Mrs. Wanzer asked who was there? I answered a friend—she enquired what a friend wanted at that time of night? I answered to stay all night. I walked away from the door and laid my hat under a peach tree about two rods distant. I stood there about five minutes with my gun cocked and pointed towards the door intending to shoot him if he opened it. He did not make an appearance and I retired to his barn and slept there till sunrise the next morning when I went into the bushes and continued firing my gun at intervals in the neighborhood of his house all the day on Tuesday; once I shot at Mr. Wanzer's fowls. He was at work in his garden and buckwheat most of the day. At one time I lay within thirty yards of him, with my gun pointed toward him, and said to myself, "how I will pop him over tonight." The family all went away at one time, and I took a circuitous route thinking to go into the house, but on reflection the thought occurred to me, that they might return and find me there. I indulged the hope that Wanzer would come into the bushes and I would shoot him there. As soon as it was dark I went to his

barn and thence to his dirt cellar. The little dog went away while at the barn and I whistled low for him two or three times. I pounded on the dirt cellar and then stood with my gun ready thinking he would come out. He did come around the corner of his house but went in again immediately. I then went in front of the house, took off my hat and laid it under the same peach tree I laid it the night before.

I whistled to induce Wanzer to come to the door, but he did not come. I went up to the house and looked in at the window adjoining the road. As I looked in some of the family said "hark" Mr. Wanzer's gun stood up against the wall, he took it in his hand and went to the door. I stood there ready to shoot him if he came to the corner of the house. I trembled very much all the time I was there. From thence I went by the dirt cellar into the road and put my gun through the fence. I stepped into the middle of the road got a stone and threw it against the house. Within a minute after I saw Mr. Wanzer coming down the path with his gun in his arms. He came within a rod and a half of where I lay. My feelings were such that I did not take particular aim, fired, intending to hit him in the breast, he sprung up, threw back his head, gave a loud groan, and fell apparently without bending, wheeling around at the same time. I then ran into the bushes and whistled for my dog eight or nine times—my dog followed and I went on through the bushes. I did not go through the oat field—I did not make the tracks Esq. Wilson testified to. After a little time, I stopped to think, and O! how bitterly I regretted that I shot Mr. Wanzer. I said aloud, "how the devil will tempt any one, but he shall never tempt me to do the like again; I will get my living hereafter by honest industry or die!" I felt exceedingly dizzy, and did not know what to do. I loaded my gun but could not recollect immediately after how it was charged. I then drew off the charge and reloaded it, to be certain it would go. I started and ran again, with such feelings as I cannot describe, until I came to a brook, which was running very rapid. Again I stopped to reflect---putting my hand on my head, I discovered my hat was gone. I involuntary cried out, "What have I done!" I made a struggle to collect my thoughts---at length it occurred to me that my hat was under the peach tree in front of the house—I thought it would betray me—I went up to the road—Ino, my dog, ran up in the woods and barked, he was on the track of something—I said," that dog means to betray me yet." When he returned I drew up my gun to shoot him, when the thought struck me that I should be heard. I mashed him down with my hand and sat down and listened. I pulled off my boots—left them in the road—took a circuitous route and got my hat from the peach tree. No one was at the house---the place was awfully still and solemn. I went on the road towards Isaac Jaycox's some distance—turned up in the woods on

a side hill, and laid down all of an hour and a half. While laying there my dog went away. I had not proceeded far from that spot, when on feeling in my pocket, I discovered that my powder horn was gone. I went back to search for the powder horn, but could not find the place where I had lain. Whilst searching for the horn, my dog met me. Returning to the place where I left my boots, and putting them on, I followed the road towards Isaac Jaycox's a quarter of a mile, when I struck off in a southerly direction, expecting to come out in Isaac Jacob's open fields, but come out by Samuel Denny's, the husband of Mary Denny, on the turnpike. Then I knew where I was. I passed by Samuel Denny's but it was all of two hours after I shot Mr. Wanzer. I made an attempt to get into Joseph Ferris' barn but failed Leaving Mr. Ferris' barn, I followed the turnpike to Thomas Jaycox's, took his buffalo skin, blanket and whip from his barn, and lay in the woods until the sun was three quarters of an hour high the next morning. Then taking a southerly course, I had not proceeded far when I was induced to stop for fear of wetting my gun, as the leaves were very damp. Shortly after I heard a rustling in the bushes behind me, and supposing it might be some one in pursuit, I proceeded on. I lay in sight of Andrew Miller's house some time. Whilst there, Daniel Ferris' boy rode up to Miller's house on a horse and told Mrs. Miller that Uncle Wanzer was shot the night before, and they suspicioned little George Denny. My object in laying there was to get an opportunity to get something to eat, and get what money I could find. What Daniel Ferris' boy said frightened me. I then went south, below John Brower's and crossed the road—went into Joseph Ferris' woods and turned my course for Shanandoah. As I was going up, I heard a wagon coming, and discovered that Andrew Miller and Rufus Gillet were drawing cord wood, but by stepping a little to one side, they did not observe me. A little further on, I got some apples off a tree—went across Forge Hill, and came into the turnpike a little west of Henry Concklin's, and following the turnpike till I came to a cross road, which I took. I came out by Elijah Horton's. I talked with Elijah Horton. He took my gun and discharged it. I had conversation with Benjamin Mulcox—he told me that Wanzer was shot the night before in his left side—he intimated that I was suspicioned. A short distance from Mulcox, Wixon and Booth arrested me. They said, George is this you. Booth looked at my gun to see if it was loaded. I told him it was not. They slapped their hands on my shoulder and said, "You are our prisoner." I asked them what they meant. Booth said you are a good for nothing murderer. I answered that I had not shot any man. Then they took me to Wixon's and then to Wanzer's. As to my motive in going to Wanzer's I do not know what to say. When I came to Thomas Jaycox's on Monday, many thoughts crossed my mind. At one time I thought of going to

John Brower's, about three miles southeast from Wanzer's, to kill him and his family—to rob the house and set it on fire. I thought that Rufus Gillet lived close by and he would detect me. I also thought of robbing Uncle Joseph Ferris' house and of killing him and his family; but I said some one lived with him and I might be detected. I turned from these thoughts. I also thought at one time I would kill Wanzer, his wife and children—drag then in the house, and set it on fire; but I have doubts whether I was sincere in my reflections to their fullest extent; as after I had killed Wanzer, I thought no more of his wife or his children. As to the witnesses who testified against me, I have no other desire than to corroborate them as so far as they stated correctly, or as far as their testimony related to me. Peter Vantassel who was most suspicioned, as near as I can recollect told the truth. I do not recollect telling Derbyshire "that I wanted to shoot three or four, and that if Uncle Wanzer did not hush up about the key, he would be the first one." I told Derbyshire when I bought his gun, that the money I paid him, I took from Andrew Miller's trunk, and he promised not to divulge it. I have no recollection of saying to John A. Miller, "I would fix Uncle Wanzer yet." John Garrison's testimony had no reference to me he did not see me. I was but a short distance from Wanzer's house all day on Tuesday. There were but two kinds of shot in my gun, beside the ball, when I shot Wanzer. I picked the smaller size out when I charged it. And I now solemnly assert that I had no bitter feelings against Mr. Wanzer at that time; and possess none now towards any individual. I do not fear death, but I cannot say how much my mind may change as the hour approaches, and I still have a desire to live as long as I can.

At this point Benjamin Bailey added the following:

Here closed his statement, the narration of which in his simple, but I am satisfied candid manner, occupied the space of three hours. Discovering probably that I was anxious to leave, after he had concluded his confession, he begged of me to not be impatient, but to remain with him a little longer. I assented. He read the 2d chapter of James, and requested me to explain the 13th verse. I replied that there were several clergymen residing in and near the village; and if he desired it, I would give them a general invitation to visit him, with which he appeared satisfied. Here I took my leave, not, however without promising, at his solicitation, to visit him frequently during the short period allotted for his existence.

Benjamin Baily.
Carmel, June 4, 1844

THE BREAKTHROUGH

A major breakthrough in my investigation happened shortly after the discovery of the newspaper article. Sallie Sypher called to tell me that a schoolteacher in the Brewster school district had worked on the Denny case for a master's thesis several years ago. She had her address and phone number and suggested I look her up. I called the teacher immediately, but found the number no longer in service, no one of that name at that address and no one with that name teaching in Brewster. After getting help from Jeanette van Dorp, a teacher's aide in Brewster, I found her. She had a married name, a new address and a new phone number. She also had a complete album of research that I was welcome to use! Her articles dated back to the time of the hanging and gave new light to the incident.

The *Republican*, in its Tuesday, June 11, 1844 edition, titled "Trial of Denny—Full Particulars," began this way:

> *This Court commenced its session on Monday of last week, at Carmel, the Hon. A.J. Parker, Circuit Judge of the 3d circuit, presiding in the place of the Hon. C. H. Ruggles, the Circuit Judge of this Circuit, by arrangement between these Circuit Judges, Judge Ruggles held the Circuit in Delaware for Judge Parker the same week.*

The article offered no further discussion or explanation of the switch of judges and I failed to find mention of it elsewhere. Why were these judges switched? Later in the article, another interesting fact came up:

> *Our readers will recollect that Denny was tried on this indictment at the last November Oyer and Terminer in Putnam, and the jury being unable to agree were discharged. The case had produced considerable excitement in Putnam, and as we understood some measures were taken to have the trial in Orange County, on the ground that it was supposed that a jury could not be found in Putnam who had not heard so much of the case as to have formed an opinion one way or the other, but for some cause of which we are ignorant the application to have the trial transferred from Putnam to Orange failed.*

Why wasn't this case taken out of Putnam County? The author of this article isn't the only one who remains ignorant and amazed as to why the application to have the trial transferred to Orange County failed.

The question might be whether the papers in the area of Putnam carried any articles that might sway a potential juror. This comment pertaining to Denny was taken from an article that appeared in the

October 24, 1843 *Hudson River Chronicle*:

> *A young man, arrested on suspicion of having committed the foul deed is now undergoing an examination. Circumstances appear very suspicious against him in this vicinity. The deceased was a very peaceable, inoffensive man. He was about 73 years of age.*

The contrast of the "hardened" criminal verses the "peacable, inoffensive" victim continued in the papers even after the execution. When the hanging was over, the *Poughkeepsie Journal & Eagle* posted a short piece on August 6, 1844:

> *EXECUTION—On Friday of last week, George Denny, a young man, or rather a youth of eighteen years, was hung at Carmel in Putnam county. He is said to have died perfectly hardened and impertinent. He suffered but justly for one of the most wanton and unprovoked murders ever committed in the country, in deliberately shooting an old man at cold spring whose house he watched and whom he called out the door for the purpose, exhibiting a perfection of depravity and wantonness frightful to contemplate, especially in one so young.*
>
> *It is said that before the execution he was exhibited upon a table, dressed in white and with a rope about his neck, to the gaze of some three thousand people, for an hour. For that act the sheriff ought to be punished if there is any legal process by which he can be reached.*
>
> *His sister waited with a wagon until all was over and then took his dead body away.*

INVESTIGATIVE SUMMARY

The ultimate question in this investigation is why is George Denny still here? The paranormals I have worked with on this case unanimously agree that not only is George not resting in peace, but he is very possibly residing in the Smalley Inn. From what I can make out, he entered the inn somewhere in the late 1980s, when Tony Porto Jr. inadvertently opened a portal to Denny's world with a Ouija board. Denny, who was made to sit on his own coffin, parade in his death clothes less than two hundred feet from the inn and hang in front of three or four thousand "neighbors," may have just happened to be a homeless spirit in or near the inn when the portal was opened.

As for Denny's short life, there are many disturbing facts. While the victim, Abraham Wanzer, was highly loved and admired, George Denny was a virtual outcast. By his own admission, his life as a child was difficult. His mother, who George was told was insane, died when George was an infant. His father abandoned the family before George was born and did not return until George was eight years old. Less than a year later, his father was incarcerated and in his confession, George describes his childhood this way:

> at about eight years of age, without friends or necessary means, after many hardships, returned to my grandfather in this county…During the time I lived with my grandfather I had an opportunity to attend school, but having the privilege of so doing, I seldom attended—my attendance at church came under the same rule. My grandmother indulged me in every evil habit, and my education in consequence is very limited. I can make out to read by spelling some of the words, but cannot write.

As for the trial, there are still more disturbing facts. Denny was tried twice. When the jury would not give a verdict of guilty in the first trial, citing only circumstantial evidence, a new trial was ordered. The lawyer assigned by the courts had been practicing for only one year. The judge assigned to his circuit switched circuits with a judge from Delaware. A request to move the trial to a county where he would get a fair trial was ignored. When the second trial ended in a verdict of guilty, he was sentenced to hang in the center of town, where four thousand people watched. In Jewell's words of 1923, "So unusual were the circumstances of Denny's execution, marked as they were by public parade, the holding of his funeral while he sat on his coffin preceding the hanging, the assemblage of hundreds of people from all parts of the county, and the veritable declaration of a local holiday, that the facts as gathered are presented here so that they may not be lost to future generations." Just days after sentencing, though Denny pleaded his innocence all along and had already been found guilty, he is said to have made a sixteen-page confession to his lawyer, who presented it to the judge. The book was bound and sent to a printer for publication. The grammar, vocabulary and punctuation were remarkably good. Most interesting is that George Denny, according to this confession, could barely read or write and seldom attended school. It should be noted that Bailey claimed in the introduction of the confession that the day he got the confession from George, he came upon him:

engaged in reading his bible. Having said that I was pleased to see him endeavoring to prepare for the awful doom which awaited him, and from which I presumed there was not the most distant hope of escaping, I requested him as one who had taken a strong interest in his favor up to the time of his conviction, and who desired to lend his best efforts towards ensuring him peace in his last moments, to frankly and fully give me the history of himself, and especially of his participation in the crime of which he stood convicted. As I anticipated he declined…He at length consented, and gave it as follows…

If this confession was his lawyer's transcription, how much license then did Benjamin Bailey take in "recording" this "history of himself" and "full participation in the crime for which he stood convicted?"

I do not believe, given the testimony of the witnesses and the facts surrounding the case, that George Denny was guilty "beyond reasonable doubt" of the murder of Abraham Wanzer. He, in fact, was never convicted of any crime other than the Wanzer murder. I do believe that there is good reason to remember his life. Some say that it takes a village to raise a child. Is it also true that it takes a village to hang one?

We should look closely at the quote to parents in Denny's confession. Whether these words are an interpretation of Denny's own words or a direct quote from Denny, they should be considered carefully:

Here I would say to parents, and to all who have the charge of children, cultivate in them habits of industry and honesty, as I have every reason to believe, if my mind had been turned into the proper channel in my infancy, I should not be where I am.

As to why George Denny is not at rest, I cannot say that it is because he was "innocent without reasonable doubt," but I can say that he was, without a doubt, wronged. For the essence of George's story, let us turn to a verse of the poem written by the essence peddler in 1844:

> *No soul in Heaven can find a place*
> *Who slights the day and means of grace;*
> *Poor George is gone I give you charge;*
> *Mourn for yourself and not for George…*

The Ghosts of Smalley Inn

INTRODUCTION

It was 11:30 a.m., half an hour before my scheduled rendezvous with the Katonah Paranormal Team. I walked into the Smalley Inn and saw Tony Porto Sr. at the bar. He was at the end stool working on his bills. Two or three elderly patrons and a couple of construction workers were watching TV and having lunch. I stood quietly for a moment, appreciating the fact that I had not yet been noticed. Memories of my previous visits were swimming inside my head. Were the ghosts aware that I had come in? Where was George, the eighteen-year-old who had been hanged less than five hundred feet from the inn? I recounted the Saturday morning visit I had made with the paranormal team. A chill went through me as I remembered how my temperature had dropped when I tried to address George Denny about my investigation on him. Details of the shotgun murder, the hunt for George, the arrest, the trial, the confession and the hanging rushed through me.

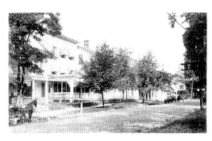

Smalley Inn postcard. *Courtesy Betty Behr.* Smalley Inn, circa 1940s. *Courtesy Betty Behr.*

Smalley Inn, 2007. *Courtesy of the author.*

"I know you're here, George," I said silently. "And I know why you're here. Now I want to know who is in here with you. Are there really nine ghosts haunting this place? Will you talk to me today, George?"

There were no chills, goose bumps or answers when I addressed him this time. But maybe he just wasn't ready for me. I took a deep breath and headed toward the bar.

"Hey, my writer is here," Tony said when he saw me. He was sitting in his usual place wearing a grey T-shirt and shorts. I was wearing a sweatshirt and khakis and was trying to look casual. "I thought the paranormals were coming," he said.

"They'll be here," I told him. "Are you ready for us?"

"Sure," he answered. "I've just got a couple of things I have to do here. Are you all having lunch?"

"Of course," I said, "if you have any eggplant parmagiana."

He smiled and leaned over his stack of unpaid bills. "We always have eggplant parmagiana," he said. Just beyond him was the door to the rear end of the basement. It led down to the liquor room where I had first encountered George Denny. The hair on the back of my neck began to rise in the familiar way it had before. "Are you here, George?" I asked silently. The memory of my having been surrounded by paranormals with Buddy Banks asking spirits to "show themselves"

Tony Porto Sr. *Courtesy of the author.*

and to "manifest" came rushing back to me. I felt the goose bumps on my arms. My temperature began to drop.

"You want to get by me to go downstairs before they get here?" Tony asked. "Are you all right? You look pale."

"No, I'm all right" I said. "I'll wait until the others get here."

The waitress came in from the dining room and said, "Hi. Are you back to find the ghosts?"

"After lunch," I said. "Are they here?"

"They're here," she said. "Are you alone? Do you need a table?"

"I have three other people coming. Can I have the table by the mirror?"

I walked over to the "haunted mirror" and stood looking into it before setting my equipment on the table. I had my tape recorder and earphones, my digital camera and my notebook. I was alone in the dining room and thumbed through my pages to see what notes I had taken on the mirror. I needed to keep my mind off George's ghost. I had a folded newspaper article from the *Reporter Dispatch* from Sunday, November 5, 1995. I had tucked it into one of the pages of my notes on the inn. It featured a photo of the former Town of Carmel historian, Marilyn Cole Greene, looking at her reflection in the mirror. The article referred to the mirror as one that "had seen many years of history reflected in it since its

creation in the early 1850s." It was believed to have been made in Paris, France, and shipped to Carmel in 1852. Its mahogany-and-walnut frame stretched ten feet in length and forty inches in height, and it weighed over four hundred pounds.

THE HAUNTED MIRROR

I reread some of my facts to keep myself busy. The length of time the mirror had hung behind the original bar of the inn is uncertain. It is certain that it was removed after the devastating fire of 1927 that nearly destroyed the inn. It was then taken to the home of Joseph B. Smalley, who was James J. Smalley's son.

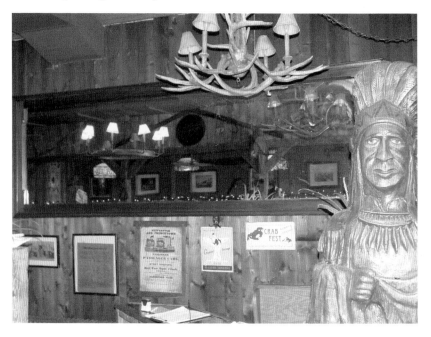

Haunted mirror. *Courtesy of the author.*

The mirror has been the subject of countless ghost tales. Patrons swear that they have seen faces in the mirror and I remembered again my own daughter saying she was nearly frightened to death when she saw faces that should not have been in her photos. One photo from a paranormal resembled a fetus. Chills ran through me. Karen Darby felt she had been contacted by a new mother who may have had a miscarriage or abortion in the inn. Another customer saw baby shoes

dangling in the mirror. I looked up carefully to examine the mirror closely. Thankfully I saw no faces other than my own.

THE ARRIVAL

Ghostly fetus.
Courtesy Barry Pirro.

As I tried to recall some of the tales, my guests arrived. The inn was instantly filled with voices and happy greetings. Kathy O'Donnell Piccorelli, Karen Darby and Buddy Banks came in ready for business. We were prepared to pick up where he had left off on the first investigation.

"I'm not going anywhere until I've had my eggplant parmagiana," Kathy joked, and Tony Porto Sr. came in to join us. After the initial greetings, he fidgeted, anxious to speak as I adjusted my tape recorder. He called the waitress over to take our orders and asked, "Are you ready for me?"

The group quickly got themselves prepared and moved in closer to hear what he had to say.

"We're ready," I said. "I'd like to hear as many stories as you can remember about the place. I know you've shared some of them with us already, but I don't want to miss any of them. Can you tell me the first time you actually encountered a ghost here?"

THE GHOST IN THE BEDROOM

He sat back and took a deep breath. "It happened to me before the radio stations started coming here with their equipment. I believe it was in 1994, July or August. I know it was summer because it was air conditioned down here and at four o'clock a.m., when I closed the bar to go upstairs, it was getting warmer and warmer with each step up. I have a one-room apartment upstairs where I live. I have a large California bed in there with mirrors on the ceiling."

He smiled and said, "That's probably more than you should know."

We laughed and he continued.

"It was so hot up there I just took off my clothes to sleep in my underwear."

"That's also more than we should know," I said, and we laughed again.

"Anyway," he said, "I plopped on my belly and fell across the pillows with my hands folded. I wanted to review all of the things I had to do for the next day so it would be fresh in my mind when I woke up. I wasn't in bed for more than five seconds when I felt coolness come into the room. I said, 'Wow, I must have left the bathroom window open. There's a nice breeze coming in from the lake and I'm going to sleep like a baby.' Three seconds later, my left leg moved down on the mattress. It moved down like when someone sits next to you on the couch. My heart went right to my throat. I froze like an opossum and couldn't move. I thought I was getting robbed. I imagined that someone had come up from the fire escape, which we've since removed, on the other building and came across to my window. I wanted to say, 'I didn't hear you come in through the window. I didn't hear you come up to my bed. Rob me. Go back outside, and leave me alone. I don't care what you take.'

"My heart was beating a hundred miles an hour. All of a sudden, the mattress on my left side went down. Now my heart was going even crazier and I was thinking that he was putting his hand down to get ready to whack me. I crunched my shoulders to get ready for it and my elbow went down. Whoever it was, was laying along side me! I couldn't take it anymore. I jumped out of the bed and bounced onto the floor, but jumped right back up again. I looked up into the ceiling mirror; no one was in the room with me. I froze. The indent was still in my bed and on the pillow but no one was there. My adrenaline was so high that I couldn't stay still. I was going to turn and run but as I turned, I looked at the bathroom window; it was closed! My other window was also closed. I knew I wasn't dreaming and couldn't have been sleeping; I had only been up there for a few minutes before all of this had started happening. I looked at the bed and it was normal again.

"I stood there waiting, but nothing else happened. I was exhausted now and just climbed slowly back into the bed. This time I laid down face up. I lay there awake waiting for something else to happen but nothing did. I was awake almost all night. I couldn't have gotten more than ten minutes' sleep.

"The next day, all of the construction guys came in for lunch. I had to tell them about my experience. One of the guys said, 'You were just visited by a friendly spirit.' Another guy said, 'Yeah, on your bed! Was it a man or a woman?'"

Tony made a funny face and we laughed, then he said, "You know, they have to make jokes, but it wasn't funny when it was happening. I just know that someone or something had been next to me. I felt the weight of it on my pillow and alongside of me."

A History Lesson

I stopped him before he could begin another story. I knew he had plenty of them to share. "When did this all begin?" I asked. "Why are there ghosts in your inn?"

"I think there is more than one reason," he said. "I was told that during the 1700s there were battles near here and they collected bodies and stored them in the basement. There is a cemetery less than a block from here. They stored them here until the holes were dug. Their spirits are trapped here. For whatever reason, they didn't leave here."

"When did you take ownership of the inn?"

"In 1968," he said.

My mind went to the deeds in my briefcase. All of the copies of the deeds from the former owners are in there, including his and James J. Smalley's.

Elizabeth Smalley's Gravestone

"And you've had plenty of encounters with spirits. Can you tell me about Elizabeth Smalley? I understand that your son and some of your guests may have had encounters with her. I believe there's something about your having her gravestone here?"

"Yes," he answered. "I acquired that in the eighties. Some construction workers were doing work out here on Gypsy Trail Road. They were making a foundation for a house with a backhoe and they pulled a tombstone of a little girl out of the ground. It said 'Elizabeth Smalley.' They brought the stone here because of the name."

"Did you ever take pictures of that stone?"

"If there are pictures, they were taken by the customers. We used the stone as a Halloween decoration. People are always taking pictures of our decorations."

"You used a real gravestone as a decoration? Where did you display it?"

He turned and pointed to the main dining room. "Right in there by the fireplace. I don't remember exactly where it was right now. We had to prop it up against the wall because it was about seventy-five to a hundred pounds. We couldn't move anything that heavy around very much."

"How long was it out here?"

"Just until after Halloween, then we put it under the stairs in the basement."

"And it stayed there for a while?"

"That's the interesting part of the story," he said. "There was a lady looking up her family tree across the street at the county clerk's office. She was related to the Smalleys. She found out from the people there that we had a tombstone of one of her relatives here. She came in and quietly had dinner and then asked the waitress if the owner was here. When the waitress told her I was in the back working, she said, 'May I see him?'

"The waitress came running into the kitchen and I said, 'When I'm done cooking, I'll come out.'

"I finished what I was doing and went out to ask her what she wanted. She said, 'I understand you have a tombstone of a girl who died young.' I told her that yes I did and that it was downstairs in the basement. She asked if I was willing to sell it. I said, 'Not really.' I was thinking, *How do you put a price on a used tombstone?* She asked to see it. I thought about it and said okay. I went downstairs and lugged it up to her. She said, 'Uh, huh. Are you willing to sell it?' I still wasn't sure about selling it, so I put a high price on it. I told her I wanted two hundred and fifty dollars for it. She said, 'Will you take a check?' I said, 'Sure, do you want me to put the stone in your car?'

"She said, 'No, my chauffer will do it.'

"Her chauffeur was waiting in the car while she was inside eating. I should have put a thousand-dollar price tag on it." He laughed as I asked him questions.

"Do you remember anything about her? Maybe what she looked like?"

"I remember she was a writer."

"A writer?"

"Yes. That's what she said she was. After she signed the check she said she was writing a story about her family."

"Do you remember the name on the check?"

"Are you kidding? That happened in the eighties. I only know she lived in Manhattan and had a chauffeur. That was the last I saw of her and the stone."

"People have said that there were sightings of a little girl here at the inn. Is that true?"

"My son had an experience with that. You'll have to ask him."

Before checking with Tony Porto Jr., I took a trip to the cemetery down the block from Smalley's Inn. I seemed to recall Betty Behr, a historian with the Kent Historical Society, saying something about James J. Smalley's daughters having been buried there. Esperanza and Emily Jane were there, but Elizabeth wasn't.

Smalley sisters' tombstones. *Courtesy of the author.*

More Haunted History

I sensed that Tony had told me all he was going to about Elizabeth and I changed the subject. "There are also rumors that someone may be buried in your basement." I said.

"Yeah," he said. "One psychic said someone is buried here. His name was Psychic Al from K104 radio station. We have pictures of him. He was downstairs where he did his thing and he was feeling that someone was buried in the floor down there. He said he felt the presence of bones. It's all poured concrete down there and I told him I wasn't about to start digging for bones. In any case, this is a historical landmark and we can't just do what we want. We actually may dig in that spot to have a higher ceiling so that we can use the space down there for customers. I had to go to New York with my engineer to get an approval for our plans down there."

"According to my notes," I said, "you bought this place in the late sixties and it had already been a tavern for a while. It became Smalley's in 1852, but it was in business long before that."

"Yeah, that's right," he said.

I pulled out a notebook and tried a few more facts on him.

"The hotel that became Smalley's was built in 1833 by Thomas Taylor, who was born in Jamaica, Long Island, in 1784. Taylor died August 1, 1865, at the age of eighty. James Smalley took it over in 1852. In 1867, according to the *Reporter Dispatch* article, it burned, and then again in 1924; it burned again in October of 1974."

"I guess that's right," he said. "In the early 1900s they had a fire. Before then the hotel took over the whole block. After the fire, it was divided into the small stores the way it is now."

Several customers entered the restaurant and Tony interrupted the interview. I turned to the team and they were discussing some of the things Tony had said. Karen and Kathy wanted to go down in the basement and I told them I was willing. We could continue with Tony when we got back upstairs.

A TRIP TO THE BASEMENT

We made a small parade to Tony's stool at the bar and walked around it to the doorway leading to the rear end of the basement. I poked my head into the kitchen and announced that we were going downstairs.

As I passed the walk-in locker, I recalled the story of a busboy. Apparently, he went in there to get something and the door locked behind him. The bolt jumped across the latch and locked him in there for twenty minutes. It was blamed on a prank played by young Elizabeth, the ghost. She is also known to poke people and pull on people's shirts and blouses.

Buddy started in immediately once we were downstairs, as he had done during our first visit together down there. "Can you turn the light on for us?" He was addressing the ghosts. The first time we were here, he had asked the spirits to dim or turn out the lights and it worked several times. We had all stood fascinated as his commands seemed to be answered. This time, there was no response. Was it the time of day? Was it that certain spirits were simply not present today?

Buddy began taking photos and Karen called him over to her. "I just saw something," she said. "Take a shot there."

"Ooh, I saw something. A blue orb," she said.

I remembered their explanations of orbs. They said that these were lights that show up sometimes in photos indicating a strange presence that was likely supernatural.

"C'mon," Buddy said. "Manifest. Show me your presence. I don't want orbs right now. Turn the light on and off."

Meat locker in the basement. *Courtesy of the author.*

I left them for a second and my eyes fell on the liquor room. It was where I had felt George's presence the first time I had been there with this team. I waited for the strange sensation to overtake me, but nothing happened. I stood in the doorway looking into the small room, then entered the room slowly. Something was starting to smell and I couldn't identify it. It was musty and damp and cold. A memory came back to me of a visit I took with friends to a cemetery years ago when I was a teenager. Vaguely, I remembered a place called the Blue Crypt. Behind me I could hear Buddy insisting that the spirits manifest. It seemed like it was coming from very far away.

"Look at this," Kathy said. "I see a blue light near that beam over there, but it won't come out on my camera."

"Something just punched me," Karen said from the meat locker behind us.

My mind whirled to the story that Linda Zimmerman repeated from Tony about a busboy being locked in the meat locker for over twenty minutes.

"Are you here, Elizabeth?" I asked. I waited. Nothing.

"George? Is it you?" I asked. Nothing.

Kathy said, "Big John? Are you here?"

"Who are you? Do I know of you?" I asked. A chill started at the base of my spine and began to crawl upward.

"Big John?" The chill intensified and I felt the coolness flow through me.

Buddy joined us and asked, "Who is Big John?" Kathy explained that she had felt him several times. Her first encounter was at her very first visit before I became involved. He had communicated to her that he had been a slave.

"Big John was talking to me," Kathy said. "He was asking why they were making this mess and blaming it on him. He said he didn't think he should be blamed. I tried to get him to say more and give me details, but we were so many people at the time and there was a lot going on."

"Big John?" I called.

"Is it you, the young girl?" Buddy asked.

"No," Kathy and I answered. "It's Big John."

"Are you buried down here? Are yours the bones that people have felt beneath this floor?" Buddy asked.

My mind went to an interview with Betty Behr, the longtime Kent historian. "Many people believe the inn may have been part of the Underground Railroad, but we have no real documentation of that in the historical society files."

My strange shivering sensation returned.

Buddy, Kathy and Karen all said at the same time, "I feel cobwebs."

We stood in total silence. And then we all started speaking at the same time.

Buddy said, "Show yourself."

Kathy said, "Can we help you?"

Karen said, "Are you here?"

I felt the need to plead with the spirit who was making its presence known to us. "How can we free your soul, John? Is it you, John? George Denny? Are you the one here with us?"

Suddenly, Buddy's voice got loud. "Don't be such a candy-ass ghost!"

The three of us turned to Buddy and stared at him in amazement, and then we broke into uncontrolled laughter.

I was finally able to stop laughing enough to say, "Buddy, I don't think calling him a candy-ass is going to make him appear to us."

"It might make him mad," he said.

The mood was broken after that. Though we made several attempts to contact other spirits, it was futile. We went upstairs to get our lunch and debrief our experiences. After eating, I toyed with my tape recorder to prepare for Tony Sr. I played back the last words of Tony's interview.

"Did it come out okay?" he asked as he returned.

"It came out fine," I said. "Are you ready to begin again?"

THE PHONE CALL

"Did I tell you about the time when I had just gotten married?" he asked.

"I don't think so," I said.

"Right," he said. He sat back down again and the team moved in close to us.

"I got married in 1998 and the only place I had to go to was upstairs. We were house hunting but we hadn't found anything. It happened around four o'clock in the morning. It seems that everything happens between four and five in the morning around here. The place was closed and the phone rang. My wife answered it because it was on her side of the bed. I heard it ring and thought maybe it was one of my kids. I was afraid something was wrong; they wouldn't have been calling at that hour. I had my ear tuned in and she said, 'Hello, what can I do for you?'

"The expression on her face changed. The caller on the other end said, 'Hellloo, what can I dooo for yooou?' It was mimicking her voice.

"She said it again, a little more agitated. 'Hello, what can I do for you?'

"The voice on the other end mocked her again.

"Now she was angry and handed the phone to me. 'Here,' she said. 'It must be one of your drunken friends who wants to get bailed out of the sheriff's office.

"I took the phone and repeated the exact words my wife had said, 'Hello, what can I do for you?'

"The response was the same one my wife had received, 'Hellloo, what can I dooo for yooou?'

"I put my hand over the receiver and whispered, 'Check the caller ID. This call has to be coming from somewhere.'

"She checked the caller ID and discovered that it was coming from the pay phone downstairs. The call was internal.

"Right away, I thought that someone had broken into the place. I figured that they were pranking us. What they didn't know was that I had two great big Rottweilers; one was 125 pounds, and the other was 169 pounds. Both of them were males and these boys were not friendly animals. I had them trained. When the place is closed, no one is supposed to be in there.

"I called them and took them downstairs with me. I was hoping to catch these guys in the kitchen playing with my phone. When we got into the bar area the dogs headed right for the exit door the way they usually

did when they had to do their duty. I called them back in a whisper and they were confused. They finally came back to me then headed toward the door in the kitchen. Their noses went up and they started smelling the air. I whispered for them to come to me but they wouldn't come. They started nipping at each other as if to communicate. I walked to them, and opened the door.

"The pay phone was on the hook and the kitchen was empty. There was no trace of anyone downstairs at all."

Pulling Tony's Leg

"It seems the place is pretty active in the morning," I said.

"They seem to like it best at that time, but they come around when they want to. On Sundays, I usually sit at the bar when we're closed and do my bills. I put on the TV and spread the bills out in front me. This one time I was sitting there and something came up and tapped me on the back of my foot. I jumped right off the stool. It felt like a cat had come up to rub against me wiggling its tail. I looked around but didn't see anything. I got back on my stool and started working again. Five minutes later, it came from the other direction. I jumped off the stool again. I looked down at the floor and shouted, 'All right you guys, you have the whole restaurant to play around in! Leave me alone. I have work to do here!' I went back on my stool, and that was it. They stopped bothering me."

The Waitress and the Chandelier

"I have some notes here about some incidents with a waitress who had trouble with the spirits," I said. "Can you tell me more about her?"

He shook his head and said, "We had a waitress who dressed sort of different and I guess the spirits didn't like that look. They didn't harm her, but they liked to scare her. One time she went downstairs to get ice, and the ice scooper was thrown at her. It was thrown at her feet and she blamed us in the kitchen, but we didn't know anything about it. She got really annoyed but she went back down and nothing occurred until months later.

"We were all busy with customers and she was standing over there by that chandelier that's not lit over there."

He pointed. "That light came down and came within inches of hitting her. She came running into the kitchen yelling, 'Tony, they're out to get me. They're trying to kill me. They're trying to kill me.'"

Courtesy of the author.

I looked around at the team and they were all listening intently. "Is there anything else that you can remember happening? Any particular sights or sounds like footsteps or voices or—"

HALLOWEEN FOOTSTEPS

"It's funny you should say footsteps," he said. "This past Halloween we had our Halloween party. We always throw a big Halloween bash. At the end of the party, when we had finished cleaning up, I told my son I was going next door to the diner to get something to eat. It was three o'clock in the morning. He said, 'Okay, don't order any food for me until you're done eating. I should get there about that time.' He wanted to finish up a few things and get some final cleaning done. Just as I ordered his food, he came into the diner. He reminded me that I had to put an order into one of the distributors, so I left him there to wait for his food and went back to the restaurant. I went downstairs to make a list of the things we needed and I heard footsteps upstairs over the bar. I said to myself, 'Man that was awful quick. He got his food pretty fast.' His wife was upstairs in the apartment and I thought I'd go up to check to see what was going on.

"I didn't see anyone there. I didn't want to go up to the apartment because I knew his wife was sleeping. I figured, well, it had to have been him. I'll check with him in the morning. The next morning, I asked him if he had followed me right out of the diner. He said no. He had eaten right there and stayed there talking about forty minutes. I asked about his wife and he said she hadn't gotten out of bed. The question was, Who had been walking around in the restaurant above me?"

"All right, then," I said. "Anything else?"

THE CIVIL WAR OFFICER

"Did I tell you about the woman who we trained to be a waitress?" he asked.

I smiled and checked to be sure my tape recorder was still running. "No," I said.

"There was this woman about thirty-one or thirty-two years old. She had never been a waitress before and wanted to try her hand at it. I said, 'The only way you're going to learn is by shadowing the other waitresses. You'll pick up the way they set up tables, take orders and bring out food. It'll be training and I can't pay you for it.'

"'That's okay,' she said.

"She started on a weekday, when it's quieter. Two other girls were on and she started shadowing. She was learning where things are up here and in the basement. When the weekend came, she came to work again, only now it was busy. The girls who had always gone down with her to get things in the basement were too busy to go with her. Generally, because of everything that happens here, they go down there in pairs. Even today there are girls who won't go down there without the bartender.

"Anyway, we needed creamers and the waitress asked her to go down to get them. She said she didn't want to go there alone, but the girls said that they were too busy to go with her.

"She finally agreed to go down by herself. She turned the light on and the light traveled down by the liquor cabinet. As she opened the door of the walk-in cooler, she noticed something out of the corner of her eye. There was a man standing back there in a military uniform. His arms were crossed and he had a big handlebar mustache, a cowboy hat, a sword at his side, striped pants, cowboy boots and a huge belt buckle. She let out a scream and ran up the stairs shouting, 'I saw the ghost! I saw the ghost!'

"I was upstairs and heard her coming. The bar was full. I said, 'What is it? What's going on?'

"She said, 'I saw him! I saw the ghost downstairs.'

"'What were you doing down there?' I asked.

"'Getting creamers,' she answered.

"The door was wide open and I asked where she had seen him.

"'By the liquor closet,' she answered.

"I took her down there and we looked back by the liquor closet. 'Do you see him now?' I asked.

"'No,' she said.

"We got the creamers and went back upstairs. After she finished for the night I never saw her again."

We laughed when he said that and I said, "Gee, I wonder why."

He was on a roll now and recalled another story that had occurred at the table where we were sitting.

BABY SHOES

"Right at this table there was a class reunion. It was their twentieth-year reunion. There was a girl taking notes right there in that chair." He pointed to a chair. "She looks up into the mirror and sees baby shoes dangling from the corner of the mirror. She looked at the girl next to her and asked, 'Do you see any baby shoes dangling in that mirror?'

"The girl looked up at me, then back at the mirror, and then at the girl. 'I don't see anything,' she said."

EXPLODING EGGPLANT

We were interrupted again by customers and Tony apologized for having to leave. The team decided to check out the second part of the basement. Kathy lifted her sandwich to take a bite and the thing exploded. Eggplant shot from the bread onto her lap and we all just stood there staring. One or all of the spirits in the inn was making its presence known to us.

"Did you see that!" she asked.

"What just happened there?" Buddy asked.

She looked down incredulously at the mess in front of her.

THE SECOND TRIP TO THE BASEMENT

"Still want to go downstairs?" I asked.

She brushed off her clothes, took a deep breath, and led us toward the basement door. "This should be interesting," she said.

We told Tony that we were going to go down to check the second part of the basement and he warned us that it was under construction and that there were no lights. If we were going down there we would have to be very careful. We descended the steps slowly with Buddy now in the lead. The LED lights of our cameras guided us and Karen began talking right away.

"I feel the presence of the woman I felt the last time I was here," Karen said. "She's young, maybe twenty-two to twenty-four. I'm getting a very vivid appearance of her. She looks like she has a terrible fever. Her hair is damp-looking and black. She has straight bangs and her eyes are somewhat sunken-looking as if she is suffering some sort of disease. Obviously she is a spirit and passed on. She is pale and shaking. She's crying and wearing a long white gown. She's barefooted and standing against the wall down there."

Buddy walked to the wall and confronted the spot where Karen was pointing. "Are you here?" he asked. "Were you buried here?"

"Do you sense that it could be the waitress that Tony mentioned?" I asked.

"No," she said. "This woman is from a very long time ago."

Buddy continued his attempt to communicate with her, but he had no luck. He asked a series of questions but again, nothing happened.

Karen talked again. "Her name begins with an *l*; she gave birth to a child," she said, and we all got chills at the same time.

"Look!" Buddy shouted, and we could all see something white appearing in the corner. As we moved to get closer, it disappeared.

Kathy began talking to Karen who said, "There is also a *w* in the woman's name." At this point, she lost contact with the woman. We waited a short while and then it was agreed that we go back upstairs.

THE OUIJA BOARD

Tony was waiting for us and we told him of our experiences in the basement. He wasn't surprised and I asked him again, "Tony, why have these spirits come here? Your son talked about a young busboy who died shortly after working here. Your son said he may have been summoned here with a Ouija board. Is that true?"

"My son can tell you more about it," he said.

I looked toward the kitchen and he knew what I was thinking.

"You can talk to him. He's working in the kitchen. But we're pretty busy today."

"Maybe I can set something together with him for later this week," I said.

We talked some small talk after that and we thanked him for all of his time. He went back to the kitchen to help his son. When the rest of our good-byes were over, I popped my head into the kitchen. Tony Jr. was preparing a meal for one of the customers.

"Hey," I said. "How's it going?"

"I'm pretty swamped," he said.

"Any chance of sitting with you some time this week? I'd just like to go over a few things."

"I don't know," he said. "I might have time Thursday after nine."

"That works for me," I said. "I'll be here then."

Tony Porto Jr.

On Thursday night, I was ready for him. I had played the tape for myself several times and my wife listened in.

"I'm coming with you," she said. I smiled.

"We'll go early and see if he has any eggplant ready for us," I told her, with a grin.

Tony Jr. was still busy when we got there about eight o'clock and we ordered food and sat near the fireplace. The waitress knew who I was and sat to talk with us a few minutes between servings. Then Tony came and pulled up a chair. I clicked on my tape recorder.

"Hi, Tony. You know I was here the other day to talk with your father. He told us about when he got married, about the phones calling each other, about going upstairs and feeling someone in his bed, and about the waitress and the chandelier and the waitress in training who saw the ghost in a military outfit. He actually told us a lot about what goes on here. Now I'd like to hear from you. Can you tell me about the first time you started encountering ghosts?"

He talked without hesitating. "That would have been 1988."

"And your family bought the place in 1968."

"Yes. My grandmother had it. But nothing happened until we did a Ouija board thing in the basement. We opened the liquor room door during that incident and nine—supposedly nine—ghosts came in here."

Elizabeth's Ghost

"I'd like to nail down who those nine ghosts are," I said. "I'm thinking that George Denny is one, and young Elizabeth Smalley—"

"She's definitely here," he interrupted.

"You saw her?"

"Yeah, I was in the basement using the bathroom down there and I noticed that something was moving around down there. I opened the door a crack and saw a little girl run by heading toward the stairs. It was as real as the two of us sitting here right now. I finished up and went upstairs to yell at the waitress and bartender. I said, 'Who let the little girl in downstairs?' They said, 'What little girl? We aren't even open yet.'

"I said, 'Look. There's a little girl running around here in an outfit. It's like a Catholic school outfit with a big bow in the back and checkered skirt.'

"They told me I was crazy and kept telling me that. But about two weeks after I saw the little girl I was sweeping downstairs and saw a pile of dirt that had been there a long time. I decided to try to move it out of there. I took a shovel and soon uncovered a tombstone with the name Elizabeth Smalley on it. According to the dates, she had died at about nine years old. I called my father right away and asked him about it. He said that some guys were digging up a foundation in Kent Cliffs and brought it here because of the name. I took it out and we displayed it one Halloween."

"When was that?" I asked.

"It was about a month or two after the Ouija board incident," he said.

MORE HAUNTED HISTORY

"I believe she is one of your ghosts," I said, "And I think that James Smalley, her father, is one." I watched his expression and he shook his head yes. One of his present-day waitresses had claimed to see James Smalley in the basement. I continued. "I'm also thinking—"

He interrupted again. "There's a woman," he says. "There's also a woman in here."

"One of the paranormals said there's an eighteen-year-old woman and she thinks she may have had a baby. One of the pictures we have looks like a fetus. She thinks that the woman miscarried or aborted, or was forced to have the baby downstairs. Another ghost might be a guy by the name of Big John, an African American slave. She believes he might have somehow gotten stuck downstairs. Maybe there is a tunnel down there that he got stuck in and died in."

"Yeah," he said. "The psychics keep telling me that if I dig up the basement, I'm going to find bones.

"There's also another story," he said, "that we haven't been able to find more information about. Someone supposedly committed suicide in the hotel when it was here. A young woman came in, probably about twenty-two, maybe twenty-four. She came in when all the hoopla with K104, the radio station, was going on. She came in and was staring at the picture where the face comes out all the time. She said my great-great-uncle, or maybe great-grandfather, committed suicide in the hotel. He hanged himself. And she had the newspaper article. I asked her for it. I said, 'Not to be disrespectful, but can I make a copy of it? I'll frame it.' She never came back with it or anything. I had asked the historical society about it to see how far newspapers go back. I think it happened around the turn of the century."

"I'll try to research that further," I said.

As a note to the reader, let me say that research on the suicide brought nothing.

RETURN TO THE OUIJA BOARD

"And how soon after that did this Ouija board incident occur?"

"Well, a couple of years later, in 1988, I was downstairs in the basement with a construction worker friend of mine talking about ideas for the basement. All of a sudden, he said, 'This would be a great place for a Ouija board.'

"I said, 'You mean the Parker Brothers game?'

"He said, 'Yeah, it's not a game. It really works.'

"I told him I really didn't want to talk Ouija; I wanted to talk about the basement."

My wife piped in here and asked why the guy was so interested in the Ouija board. "What was there in the basement that made him think it was a good place for it?"

"I don't know," Tony told her, "but he came with a girlfriend and another friend and asked for the power breakers in the basement. He said we had to do this in the dark with candles. He had a pad and a piece of paper to take notes, and I basically laughed a lot of it off. Even when he warned us that some of the people who come on the board may impersonate someone else and mess with us.

"We all put two fingers on the pendulum thing and he started asking it things. He kept asking it questions and it kept saying no. Then it started spelling my name out. I figured he was just pushing it to do that, but he wasn't even looking at the board and the other guy was taking notes. Then it spelled out my name again and he said,

'Tony, he wants to talk to you.' I asked who it was and it spelled out the busboy's name.

"I immediately let go of the thing and jumped up. The only one in that group who might have known the boy's name was the guy who owned the board, but it wasn't likely that he was manipulating it. I got real quiet and stayed with it a while asking questions and listening to what was being spelled out. All of a sudden we started hearing coins hitting all around us. The floor was cement and we heard change hitting the ground. I looked to the stairs but we were too far away from them for someone to be throwing coins from upstairs.

"Mike turned to me and said, 'Tony, ask him to show himself to us.'

"I was like, if I see anything I'm out of here!

"So Mike said, 'Ask him if he can blow out one of the candles.'

"I warned everybody at the table that I'd better not see them blowing at the candles. I asked the spirit if he would blow out one of the candles on the table. Right away it went to no. I thought that maybe it was someone impersonating the worker. I said, 'How do I know this is really you?'"

Tony Jr. looked up at me and said, "This next part is pretty unbelievable, but I will take a lie detector test to prove it. The spirit said, 'I threw change.' We all let go of the thing at that point.

"Mike said, 'Throw the change again.'

"It didn't answer.

"I said, 'Why did you throw the change?'

"It spelled out, 'I- O-U 1-3-8-0.'"

My wife, at that point in the interview, said, "What does that mean?"

Tony said, "A buck three-eighty. I used to give him free meals and a ride home, and when he asked me how much I owed him, I said, 'a buck three-eighty,' which meant he didn't owe me anything, although I don't think he knew that. It was the term I used to use with him that no one in that Ouija group could have known."

Tony said, "At that point I became a believer. I got so charged that I went to the group and said I wanted to run the board. At that point, another person came on the board. It wasn't the same person. He asked us to go over to the liquor room and open the door. Mike said, 'Are you a good ghost or a bad ghost?' The answer came back, 'A good ghost.'

"We asked it a ton of questions and it said he was from Carmel. He went to California and died in a hit-and-run accident. He then kept insisting that we go to the other side of the basement to the liquor room to open the door. Finally, we went back upstairs and went to the other side of the basement. All the time we were going, I told the group that

The pay phone in the bar room. *Courtesy of the author.*

it was silly because we don't lock the door he was talking about. When we got there, the door was padlocked. Mike was begging me to keep it locked. I had to open it. I always believed there was something hidden in that room. This was the room that was supposedly used by James J. Smalley when he served as a coroner for the county.

"I unlocked the lock with a key we had on the shelf and turned the light on to check the tiny room. Nothing was there. We eventually went back upstairs and down into the room with the Ouija board. I took over the board and asked, 'Are you still with us?'

"The answer came back as, 'Yes, sitting with you.'

"The thing started moving and spelling out more words. It spelled 'p-h-o-n-e.'

"The kitchen phone started ringing and we ran up to answer it. No one was there. Then the payphone rang. No one was there either.

"By that time we had had enough. It was 3:45 a.m. We went back to the board to wind things up. I said, 'We have to go now.'

"The board spelled 'H-A-H-A-H-A'

"I said, 'It's laughing at us. We've got to go!'

"The answer came back as, 'No. The nine of us want to play.'

"Mike said, 'There are nine of you in here?'

"It went to 'Yes. We want to play.'

"Mike said, 'That's it. I'm out of here.'

"I said, 'I know you want to play, but we're leaving now.'

"It said, 'We will always be with you here now.'

"I packed up the board and shakily handed it to Mike. 'Get this out of here!' I shouted.

"'I don't want it,'" he said.

"'If you don't take it, I'm throwing it out,'" I said.

"He said, 'Do what you want. I'm not bringing it home with me.'

"I threw it in the garbage. He went home to Brewster. It was like 5:30 in the morning. When I got to my apartment the phone was ringing and I was almost afraid to answer it. I picked it up and it was Mike. He said, 'I just remembered, you can't throw it in the garbage. The only way you can get rid of it is by burning it.'

"I said, 'You brought it here. You come back here tomorrow and burn it in my oven. Then you're going to take the ashes and throw them into the lake to get rid of them.'

"He said, 'Okay, okay.' But he didn't show up. A week went by and finally he showed up. He took the game with him and from that day things began happening."

INVESTIGATIVE SUMMARY

The ultimate question in this case is whether there are, in fact, ghosts in the Smalley Inn. The paranormals involved in the case are in unanimous agreement: the Smalley Inn in Carmel, New York, has unquestionable paranormal activity. A portal was apparently opened in 1988 when Tony Porto Jr. and company used a Ouija board to contact spirits at the inn. Reports from patrons indicate the possibility of the presence of at least nine spirits and possibly ten. Most noted are reports of contact with George Denny, an eighteen-year-old hung for murder fewer than five hundred feet from the inn; a former employee, possibly a busboy; Big John, a possible African American slave; an unidentified pregnant woman and her unidentified fetus; a former waitress; Elizabeth Smalley, nine-year-old daughter of James J. Smalley; James J. Smalley, former owner of the inn; an unidentified officer of the Civil War;

Kristy Farina and Mike Joyce with spirits. *Courtesy of Kristy Farina.*

and an unidentified male former resident of Carmel who died in a hit-and-run accident in California.

Documentation of sightings is weak. Historical documentation is even weaker. Testimonies of paranormals and patrons are quite convincing. My own experiences at the inn leave me with little doubt that something or someone is present at the inn. Incidents are too numerous to dispel as coincidence or pranks. My suspicion is that George Denny is a tortured soul who finds solace in inhabiting the inn. James Smalley and his daughter may be enjoying the relationship they were denied in life. Former workers may find the inn to be a safe place and have reluctance to move on to the unknown. The expectant mother may be trapped with her child in some sort of limbo between life and death. The Civil War officer and the hit-and-run victim are likely to have messages or reasons to inhabit the inn that have yet to be discovered.

In short, when it comes to the Smalley Inn, my suspicions are that dead people really do live there.

Chief Daniel Nimham
Gentleman Warrior

INTRODUCTION

On a hot New York day in August 1778, Patriot and British forces clashed in the woods, fields and rock ledges of the Bronx, formerly Westchester County, at Kingsbridge, in what is now Van Cortlandt Park. Seventeen Native American soldiers armed with rifles and muskets, quivers and arrows, tomahawks and courage, spilled British blood and fought their last fight for freedom. Their captain, Abraham Nimham, and his company, which included Chief Daniel Nimham, the captain's father, were caught in a British ambuscade. When the elder Nimham reached up for a British officer to tear him from his horse, he was shot in the back of the head and called to his people to flee, saying he was old and would die there. But the great sachem didn't die alone. Warriors fought and died bravely by his side, their bodies later strewn across the battlefield. Shortly after the battle, a local farmer discovered that his dogs had been eating human flesh. Upon investigating, he found the dead Native Americans. Daniel Nimham's body had been nearly devoured. The old chief had apparently died trying to drag his body to a nearby stream. The farmer buried the Native Americans and covered their graves with stones to prevent any more animals from digging them up.

THE CARDBOARD BOX

I grabbed a cardboard box with a dozen file folders and took a trip to the Putnam County historian's office in Brewster, New York, to begin the Daniel Nimham investigation. I knew the job was not going to be easy. Biographical information was sparse and inconsistent;

Model of Chief Daniel Nimham, by Michael Keropian. *Courtesy of Michael Keropian.*

even the spelling of his name was controversial. Was it "Nimham" or "Ninham"? The goal was to gather and sort the easily available material and undisputed facts and get them out of my way so I could struggle with the parts of the story that would be difficult to prove. The story broke down into three major categories—Nimham's life along the Hudson Highlands, his service in the French and Indian War and his service in the Revolutionary War.

After reading and photocopying dozens of articles and references from local newspapers, and gathering several somewhat reliable Dutchess and Putnam County local history sources, I discovered that there were three memorial plaques dedicated to the chief, and more memorials on the way. I was eventually able to piece together an interesting summary of Daniel Nimham's life through the articles written around the time of the dedications of the plaques. The richest information came from an address delivered on June 4, 1938, at the dedication of Nimham's monument at Brinkerhoff in Dutchess County, New York, by William B. Newell. Newell, a full-blooded Mohawk, is also known as Ta-io-wah-ron-ha-gai (Rolling Thunder). I made a copy of the article and tucked it away with a note to myself to get some of the photos from the event. Then I concentrated on getting a good paranormal team. A spirit as strong as Daniel Nimham's had to be alive and well and living close by.

INVOLVING THE PARANORMALS

I already had plans to use Kathy O'Donnell Piccorelli and her Katonah Paranormal Research and Investigation Team, but another paranormal's

name kept coming up: Penny Osborn Tarbox. My historian friends all knew of her as a pretty reliable source and I made plans to contact her. If Nimham was trying to give me signs to use her, he sure wasn't taking any chance of my missing any clues. She was in a spiritual Native American drum group called the Nimham Mountain Singers. She lived at the base of Mount Nimham in the Nimham Lake area and had a house on Chief Nimham Circle.

I got her number and gave her a call. She had read my book on Sybil Ludington and had even attended one of my talks. She said she was giving a presentation on spirits at a local library on September 17, and I was invited to attend. She also invited me to a spiritual drum program by the Nimham Mountain Singers for that next Saturday afternoon. I spent three hours listening to their music in the park. The aura around the group gave me goose bumps. I was easily convinced that the chief was speaking through their music.

The Nimham Mountain Singers. *Courtesy of Nimham Mountain Singers.*

Several weeks later I went to the talk Penny gave at the local library. She told the audience about her encounters with the supernatural and gave detailed accounts of ghosts she had seen. She had pictures. Two of the pictures were on Nimham Mountain and the spirits around her in the photo were as visible as she was. And then she looked right at me when she told everyone that she had seen Nimham's ghost. She described him in detail. Two weeks later I was sitting with Penny at her dining room table with her husband Gil, and my tape recorder.

Tarbox Interview: December 3, 2006

"Your name is Penny Osborn?" I asked.

"Penny Osborn Tarbox," she answered, and laughed softly as she looked across at her new husband. "We were married this summer at a Pow Wow in Putnam County."

"Congratulations," I said, and addressed her smiling husband. "And you are?"

"Gilbert Webster Tarbox," he answered proudly, "also known as Crying Hawk."

"You run a spiritual musical group called the Nimham Mountain Singers?"

"Yes. We're a group of residents from Westchester, Dutchess and Putnam. We formed a Native American drum group that performs at Pow Wows. We perform wherever Native Americans want to gather to hear us sing and converse with us."

"Why Nimham? What is the significance of using his name?" I asked.

He looked at me for a few seconds and said, "Good question." But he let his wife answer.

"A little before the bicentennial of the American Revolution, a friend and I decided to write about the Indians of the area. In 1972 when I moved here with my late husband, the name Nimham was all around us. The name was very prominent but no one really knew who or what the name stood for. After a while we got together with people who knew the history of the area. I found out that Nimham was a Wappinger chief and I became very interested because I have northern Cheyenne American Indian blood in me. I also found out quickly that research was difficult. There wasn't much out there. I found out quickly that his name is 'Nimham' and not 'Ninham,' as some people erroneously call him." She stopped there and went into the kitchen and I thought that she would never get to the part I had been waiting for, but she came back in and made herself comfortable.

"My first spiritual encounter with Chief Nimham was up at the top of Mount Nimham. If you travel in a southern direction from my house you are climbing up Mount Nimham toward the fire tower. I had gone up there, I think it was in the fall, but I can't swear to it. I was thinking about the Indians who had lived here and what it must have been like because the terrain is tough. When I got up to the top of the mountain, I was the only one up there. It felt like I wasn't alone. I felt the presence of spirits. I wasn't sure that they were Native Americans, but when I got up there I knew that their spirits were up there with me. I looked around for a while and climbed halfway up the tower, the tower is over one hundred steps to the top; I looked over the side then decided I was going to go back down. When I came back down I was facing a small knoll toward my right. I saw a man standing there. He was in what looked to be Native buckskin garb. It wasn't western buckskin; it was more northeastern buckskin. He was quite tall and I realized very quickly as soon as I got down there that he was a spirit.

"I'm not afraid of spirits; I've faced them before. I'm a paranormal investigator and I've been involved with spirits since I've been in

Fire Tower on Mt. Nimham. Courtesy *of the author.*

Nimham Mountain Fire Tower

Erected during the Great Depression by the Civilian Conversation Corps, the 83-foot, 6-inch fire tower still stands tall today atop the 1,244-foot peak of Mount Nimham in Kent, New York. It was one of seven thousand working fire towers across the country and was used up to the 1970s to spot forest fires. Planes and satellites have put these magnificent giants out of work. Recent renovations helped to replace the hundred and two wooden steps with steel. On a clear day, visitors can climb up the eight flights of stairs to see three counties, two states, and possibly the ghost of Chief Nimham.

my late teens. So I knew he wasn't a physical being and was more a spiritual being. I was mesmerized and just looked at him. What stood out were his eyes. They were just so beautiful and so deep, and they were crying. I just remember standing there looking at him and I can't remember if his mouth moved when he spoke to me but his words were: 'Never let them forget who I am.'

"I can remember thinking, *Who are you?* but I didn't voice that. I think I knew right then who he was. Somehow, maybe telepathically, he told me he was Chief Nimham. I think I closed my eyes. When I opened them again he was gone. On the ground was a white feather. I picked it up and felt his presence even though I couldn't see him. I said to him, 'If that's to be my mission, you need to help me.'

"White feathers have become my prayer feathers. From that time on I have always felt that he was around me and have seen his presence. When Michael Keropian, the sculptor, was doing a statue of Nimham for the town of Kent, he came to me because I was the only one who had a visual of Nimham. When the artist asked, I told him he was tall and quite thin. As far as his eyes go, look into Gil's eyes and you'll see the eyes of Chief Nimham," she said. Gil smiled at her.

"Did you say that Michael Keropian used your description to create his model of Chief Nimham?" I asked. I had seen the model and noticed she had one behind her on a shelf.

"He gave us this one for our wedding at the Pow Wow this year," she said. "He did a great deal of research on the Native Americans in this region and combined his information with what I described to him to create this model."

I made a mental note to interview Michael Keropian and have included a photo of Mike examining his model.

I was curious about the photos Penny had shown at her presentation at the library and she took them out for me to see again. When she put them in front me, Gil asked, "Do you know the story about the day those pictures were taken?"

"No," I answered.

"We went up there to do a talk. I was going to talk about Nimham and she was going to talk about Chief Seattle. When we got to the top of the tower we had our drum with us and we have this song called the 'Calling-out Song.' It is used to call out the spirits. After the song I came down from the tower and Penny read the speech."

At this point, Penny got up and put the speech in front me and asked me to read it. It had some handwriting at the top of it explaining the history of the speech.

CHIEF SEATTLE'S SPEECH

The speech was given by Chief Seattle, in 1855, when he surrendered the land on which the city of Seattle is now located. The treaty, known as the Port Elliott Treaty, doomed his people to reservation confinement. At the signing of the treaty, he addressed Governor Isaac Stevens:

My people are few. They resemble the scattering trees of a storm-swept plain…There was a time when our people covered the land as the waves of a wind-ruffled sea cover its shell-paved floor, but that time long since passed away with the greatness of tribes that are now but a mournful memory—

To us the ashes of our ancestors are sacred and their resting place is hallowed ground. You wander far from the graves of your ancestors and seemingly without regret. Your religion was written on tables of stone by the iron finger of your God so that you could not forget. The Red Man could never comprehend nor remember it. Our religion is the traditions of our ancestors—the dream of our old men, given them in the solemn hours of night by the Great Spirit; and the visions of our sachems, and is written in the hearts of our people.

Your dead cease to love you and the land of their nativity as soon as they pass through the portals of the tomb and away beyond the stars. They are soon forgotten and never return. Our dead never forget the beautiful world that gave them being—

When the last Red Man shall have perished, and the memory of my tribe shall have become a myth among the white man, these shores will swarm with the invisible dead of my tribe, and when your children's children think themselves alone in the field, the store, the shop, or in the

silence of the pathless woods, they will not be alone---At night when the streets of your cities and villages are silent and you think them deserted, they will throng with the returning hosts that once filled them and still love this beautiful land. The White Men will never be alone.

Let him be just and deal kindly with my people, for the dead are not powerless. Dead—I say? There is no death. Only a change of worlds.

A cold chill went through me.

Gil went on. "A couple of days later, the guy who took the pictures called us and said, 'You've got to see the pictures that were taken. There's an amazing one of you coming down from the tower and one of Penny when she was reading that speech.'

Penny Osborn Tarbox with spirit. *Courtesy of Rod Glosser.*

Gilbert W. Tarbox with spirit on Nimham Mountain. *Courtesy of Rod Glosser.*

"The spirit came down from that tower with me and that's why it appeared with me on the stairs," Gil said. "It kept getting stronger as Penny read the speech and appeared with her. But it is one of the few spirits that touch the ground."

Penny interrupted him here and said, "When we showed these to the elders, the one comment they kept coming back with is 'Whoever's spirit this is with you is very high in stature, a very, very powerful person, very important, that it is so big. He must have been a very big person in life for him to have a spirit like this.'"

BACK TO THE BOX

When I got home, I was excited by my information and needed more. I pulled out several articles from the *Beacon News*, written in June of 1938. The articles were on the dedication of the second

memorial dedicated to Nimham. Amongst them was part of the speech by Ta-io-wah-ron-ha-gai and it highlighted some important information from Nimham's early years. I tried to put the information together in a chronological order.

Nimham History

Daniel Nimham was a sachem, or chief, of the Wappingers, a confederacy of the Algonquian tribes consisting of nine different groups. They were closely affiliated with the Mohicans. These tribes owned much of the land along the Hudson River until it was either purchased or stolen from them. One of the most noted land dispute cases involved the Philipse family land patent. Nimham's fights in the courts both here and in England kept Chief Nimham busy for a major portion of his adult life and is clearly documented as primary sources in the Dutchess County clerk's office and repeated in several newspapers and magazine articles.

Daniel Nimham is believed to have been born somewhere between 1723 and 1726 and spent most of his younger years in the rich lands along the Hudson River Highlands. Unlike many of the Native Americans of his time, he learned to read and write. It is also possible that Nimham attended school in Stockbridge. In a passage in Henry Noble McCracken's *Old Dutchess Forever*, McCracken told us that "Stockbridge, to which place Nimham had (later) entrusted his weaker people, must have been well known to him. He had perhaps gone to school there, though he always signed his mark with an *N* reversed, as on a seal. Perhaps, after all, he could read."

At a fairly young age, Nimham became a chief sachem of the Wappingers, a position he held for thirty-eight years, until his death. In 1746, he joined the war against the French and Indians on the side of the British. He remained in a place called Westenhuck, where he fought various battles for ten years. In the next three years he was assigned to serve beside the notorious Roger's Rangers, a troop that later became the Queen's Rangers, which ironically were later led by Colonel John Graves Simcoe, one of the men responsible for Nimham's brutal death.

By 1752, at about twenty-six years old, Daniel Nimham became chief of the Nochpeen, Wappinger and Canopus tribes. In 1754, the British were complaining of threats to the colonies and were looking for help from the Mohicans. Not surprisingly, they turned to Daniel Nimham, whose warriors were known for their fighting skills and speed. In an effort to protect his people and the settlers who had become his

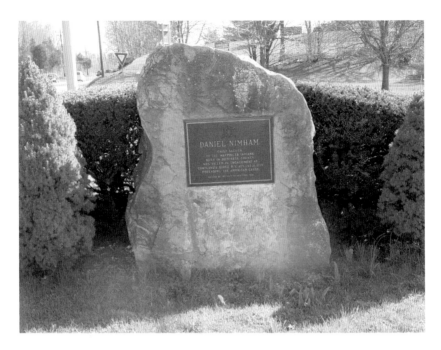

Monument at the intersection of Route 52 and Route 82 in Fishkill, New York. *Courtesy of the author.*

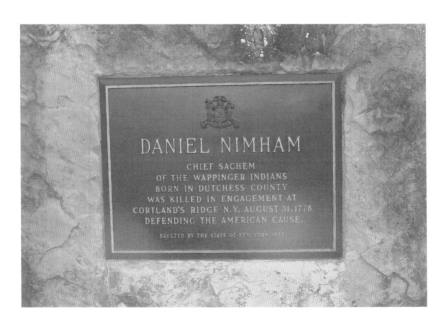

Plaque close-up. *Courtesy of the author.*

neighbors, Nimham accepted the requests of Sir William Johnson, the Crown's Indian Agent, and committed three hundred Wappinger warriors to the king's service.

In his new title as War Chief, Nimham recognized the difficulty of ruling his people from the distant northern battlefields and moved the majority of his people to Stockbridge, Massachusetts, a Christian settlement made up of Mohicans. After participating in many important battles, Nimham returned to his original home along the Hudson to find that his land had been plundered. Between 1754 and 1759, a thirteen-mile piece of land that had belonged to the Philipse family became as large as what is now Putnam County. By the time Daniel returned from the war, he found most of his ancestral land gone, taken by the very people he was protecting from the French and northern Native Americans.

In 1762, three years after the end of the war, Chief Nimham raised money with several chiefs to bring his case before the king of England. Although they did not get to see the king, they were allowed to present their case to the Lords of Trade. Their case as it was presented stated:

> The tract of land, the property and possession whereof is claimed by these Indians, and their title disputed, is situated between Hudson's river and the line which divides the province of New York from that of Connecticut, extending in length from east to west about 200 miles, and in breadth from north to south about 160 miles containing about 240,000 acres of land, that they continued in the uninterrupted possession of those lands, and in actual improvement and settlement of the same, by themselves, and their tenants, until the commencement of the late war, when the head sachem (Nimham) accompanied by all the males of that tribe able to bear arms, went with your Majesty's service under Sir William Johnson, and the residue moved to Stockbridge for their greater convenience and accommodation, that whilst the said sachem and his people were fighting under your Majesty's banner, all this tract of land was taken by person's claiming a grant thereof made by the governor of New York, by one Adolph Philipse in 1697, and afterwards purchased by him of the ancestors of the said Indians, which purpose they allege, was not a purchase of the whole tract comprehended in the grant of 1697 but only a small part of it.

Nimham received a favorable hearing and was assured that Sir William Johnson would support him in his legal case back in the colonies. The case was heard in New York City on March 5, 1767, before the governor and council, who decided that the case was "vexatious" and

that the Native Americans had no claim. In his speech at Brinkerhoff, William Newell said, "Though they fought to make a country, these patriotic Indians were never successful in gaining back their homelands. For years they sued in the courts of New York, but lost."

Chief Nimham continued to live with his people in Stockbridge and visited the few Native American villages that remained along the Hudson River in Dutchess County. He is said to have stood often on what is today called Mount Nimham, where the fire tower now stands, overlooking the land of his people.

In April 1774, the Provincial Congress of Massachusetts sent a proclamation to Nimham and his tribe to tell them of the impending war against the king. By 1775, Nimham went to Boston, Massachusetts, where he addressed the new Continental Congress and pledged himself to defend the new fledgling government. By the summer of 1778, Chief Daniel Nimham was in his fifties. Abraham, Daniel's son, was now a warrior in his own right and served as a captain in the American Revolution against England; his father fought by his side.

On the thirty-first day of August, 1778, at approximately 10:30 a.m., Chief Daniel Nimham, his son Abraham and approximately forty Stockbridge Native Americans, were valiantly exchanging gunfire with British troops under command of Colonel Emmerick Simcoe and Lieutenant Colonel Banastre Tarleton in a little-known battle of the American Revolution in the northeastern portion of Van Cortlandt Park, Bronx, New York, west of the present-day Major Deegan Expressway. The rest, as was described at the beginning of this chapter, is history.

MICHAEL KEROPIAN INTERVIEW: DECEMBER 4, 2006

Once again, I found myself in the Mount Nimham region of Kent. I wanted to know more about what Penny had alluded to when I was with her. She said Michael Keropian had done a lot of research on Nimham and the Wappingers. His house was less than a stone's throw from the Nimham memorial at Putnam County Park.

"So Michael, why Nimham?" I asked.

He sat back on one of the few stools in his studio and delivered his answer the way a college professor might deliver a lecture.

"Daniel Nimham was the head Sachem of the Wappinger people. He lived from about 1726 to 1778. He was a hero that few people know about. They talk about George Washington and other people like that but they don't know about Daniel Nimham and the Wappinger people. They know about the Mohicans and the Mohigans, they know about

the Sioux Indians, but they don't know about the Wappingers who first met Henry Hudson on his venture north up the Muhheakantuck, 'the river that runs both ways.' By the early 1800s there were not many Wappingers left in the area; many of them, including the Nimham family, joined the New York Oneidas and eventually moved to Canada, Kansas and Wisconsin. When tribes merge in this way the woman's tribe takes over the name and eventually the Wappinger name began to die out. Today the Wappinger and Nimham names are known mostly in the Manhattan to Rhinebeck Hudson River area. As to the borders going east, they went as far as Fairfield, Connecticut."

"What about documentation? Do we have any primary sources to document Daniel Nimham's life?"

"You're talking mostly about deeds. His name comes up in many deeds as he fought in court to save his people's lands. He also went out to England to fight for his rights before King George, which is documented. There are news articles here and abroad that document his travels. I believed there might have been a portrait of him that was done there and I was very interested in finding it for my work on him, but we haven't found it yet."

He went on to discuss what went on in Kingsbridge and the details of Nimham's death which was pretty close to what I had already heard, but I found his concentration on what Nimham may have looked like or how he may have dressed very interesting. My hope was that I could get a sense of what Nimham looked like for my paranormal investigations. If anyone claimed to see Nimham in any of the places we were searching I wanted to be ready to identify him and compare notes.

"Did your research on the Wappingers help you to identify what Daniel Nimham may have dressed like? I notice that you have him pretty scantily dressed in your sculpture."

"There is no real written depiction or statement from anyone I've talked to about the way he was dressed. There was a Hessian who gave a description of what he saw at the battlefield and described Indians dressed in linen, trousers and shirts. No one really knew if Daniel was dressed that way. He was in his fifties, so much older than the other Indians and he was a volunteer. Although his son was with the militia and getting paid, the elder Nimham wasn't. He would go on a battle because his son and friends were there. They would go together, work together and fight together."

"There is a discrepancy on when he was born. Do you know his birthdate?"

Mike Keropian examining his Nimham model. *Courtesy of the author.*

"Yes. I believe Nimham was born in 1726. I don't know exactly, although I know people have said 1724. I have seen it written more times as 1726. There is a good possibility he was born in the Beacon/Fishkill area of New York. His father, 'Old Nimham,' was good friends with the Brett family—in particular, Katrina Brett. It is said that Daniel's relationship with Katrina, and possibly growing up with the Brett family, was how he learned his English and how he learned to read and write. This made him advantageous to his people because he could go to court and speak to these people and convince them that taking these lands was incorrect. As I depict him in my sculpture, I have him with a roll of deeds in one hand and a musket in the other symbolizing the dual role he held all of his life; taking up arms for the cause of his people or fighting in court on behalf of them. In any case, he was always ready to fight for his people.

"You said that the Hessians depicted Native Americans in linen and trousers and yet you dressed him in a loincloth?"

"My sculpture depicts Nimham not only in a loincloth, but with linen trousers and leggings over them. I intend to try and satisfy the Stockbridge historians by adding linen trousers [to include the European influence]. The leggings and loin cloth are traditional native symbols and the naked upper body symbolizing his pure spirit. Nimham

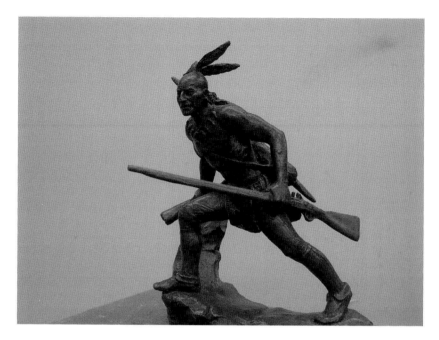

Model of Chief Nimham with deeds and musket. *Courtesy of Michael Keropian.*

crossed boundaries spiritually and physically so I wish to depict this in my sculpture."

"Let's go back to his age for a minute. He was said to have stated, 'I am old and I will die here.' If your birth date is correct…"

"Nimham was fifty-two when he said that," he finished for me.

He paused and said, "Let's go back to what he may have looked like. One of the first things I read is from descriptions by Europeans. The Wappingers were taller than Europeans, who were an average 5'4." They saw these Native Americans who were tall, muscular and healthy and eating and living very well here as compared to western Native Americans, who were much shorter. After reading a number of descriptions of the native people by Europeans, I wanted to find physical evidence and compare the skeletons of native people in the northeast with their cousins in the west who were not usually tall people. I was invited to the Smithsonian by Dr. David Hunt and was given permission to research the remains in the archives. I was directed to a facility where hundreds of drawers of Native American bones and skulls are stored. People can go there to claim their ancestors' bones. I studied dozens of these skulls to get a sense of what his skull looked like and then I went home and started my work. A lot

of the work was spiritual. I added that with some of my intuitions and suggestions from Penny Tarbox and the product became what you see.

"In July 2005 I received the following letter from a Nimham descendant:

> *Shekoli Mr. Keropian,*
>
> *My name is Matt Ireland, I am a member of the Oneida Nation in the wolf clan. I am a descendant of Daniel Nimham. Apparently, Daniel's son Abraham fathered a child named Henry. Henry was made an Oneida chief in 1804…Dorothy is my father's mother, and my next door neighbor. I've shown your sculpture to her and her sisters, as well as a few other descendants of Daniel Nimham. The common theme they all agree on is: "He looks like a Nimham—especially the nose."*

I smiled and complimented him on his good work, then asked, "Do you feel that Nimham contacted you during this project?"

"The way in which my wife and I found this house, and the way in which I got involved with this project, has all been for a reason. So, to answer your question, yes. There is some reason why I am here. There is a reason why Gil Tarbox is here. There is a reason why the mountain is called Mount Nimham. He is a strong source. I have not been visited by him. I can't give you any spooky ghost stories, but there is a spiritual reason I'm doing this project. When I sculpt someone there is a reason for it."

"Mike, I have one last question. If I get a paranormal team together to go to the battlefield where Daniel Nimham and his son were killed would you be interested in joining us?"

"I'd like to talk with my wife, Jan. I think we would both like to join you."

KATHY O'DONNELL PICCORELLI AND KAREN DARBY INTERVIEW: DECEMBER 9, 2007

I reached Kathy's house in the morning and punched in the code for her alarm at the end of her driveway. She invited me in and I got ready to convince her to join me on the Nimham investigation. We were joined by her sister, Karen Darby. I started by reading a piece of the George Denny chapter in progress and describing my reason for wanting to use paranormal research, then got right to the point. "What I'm hoping to do is write something similar to my Denny chapter, only on Nimham. I want to know if Nimham's spirit is with us."

"It is so weird that you're saying this," Kathy said. "I have goose bumps."

"Why is that?" I asked.

"Because I just found out about Nimham Mountain and all of these people who have actually seen him. I feel he's up there."

"I'll want to talk with you about those people," I said. "I met one of them myself," I added. "Her name is Penny Tarbox. I heard her speak and interviewed her recently. I hope to work with all of you on my history investigation on Chief Nimham. What I'm proposing is an interesting marriage of our work here. I am a history investigator and you are ghost investigators. What I hope is that you can help me find the ghosts and I can tell you why they are here. I'd like to believe that we are going to be great together. Can you tell me a little about yourselves and what you do? When did your interest in the paranormal begin? Can I ask you to reintroduce yourselves while the tape is running and have you tell me about your early experiences and when this started?"

"It's kind of hard to say when it all started, but it was in childhood, definitely. We were definitely very close," Karen said.

"You're sisters?"

"Yes. My name is Karen Darby. When we played together we knew there were others there with us, but we never actually talked about it. For me, it was something I could have been burned at the stake for," she laughed. "It was more like religious icons that I was seeing. I think we all see different things for whatever reason. Maybe it was a reflection of my background. My father was very religious and he took us to church every single weekend and on holy days. I would sit there bored and Mary would appear to me."

"Mary?" I asked.

"Yes. The mother of Jesus. We would sit and have conversations and she would be like any other person who would come to sit next to me. I would see angels too."

"About how old were you when this was happening?"

"I guess about five or six."

"And did this eventually stop?"

"It stopped when I got to my teens. I feel like energy changes in kids once they hit puberty and adolescence. All that rebellious stuff starts going on. You push things aside like people who passed on or angels and seeing things and don't talk about it or you will get made fun of. We both fell into a period of about ten years when all of this sort of fell asleep or we chose not to be aware of it."

She stopped talking and Kathy took over here. "My name is Kathy Piccorelli, but if we do anything in publishing I want to be known by my maiden name, Kathy O'Donnell.

"It was the same for me as my sister. It started in childhood, but I saw a lot of animals, insects and things like that, but they didn't speak to me. Spiders in particular. Spiders are very ancient. A white buffalo appeared before me and would speak to me. At that point I would get very excited. I always get excited when the topic turns to Native Americans. I have been told that I have a very strong Native American guide. That is what turned me on to this story that you are doing."

"That's interesting. Penny Tarbox said that same thing to me."

"I am sure we have a connection," she answered. "I have always, even as a child, been sympathetic to the Native American plight. I don't want to go off into my strong beliefs here—let me go back to what I was saying about being away from our feelings for ten years. It's not that we didn't have it—we ignored it. Everybody has the same gift. We are all born with sight, but we have the option or free will of closing it down."

"And you closed it down for at least ten years and then had a kind of reawakening. How or when did that happen?"

Together they shouted out "Raphael!" and Kathy took over.

"My sister lives in New Fairfield and I live in Katonah. I was out feeding the horses and there is a window in there. It was raining and I kind of looked up and there was a guy walking up the driveway. He was wearing one of those Australian dusters and a hat. I got sort of annoyed thinking it must have been someone lost and I wanted to get done and get back inside because it was cold out. I decided to finish what I was doing and when I looked up, he was gone. I had a door to the left of me with a window in it and I saw a shadow. I turned and looked directly into this guy's face looking in the window. It was weird as day. I could see every pore in this guy's face. And as soon as I did that, he began fading away. I ran into the house to call Karen and as soon as she answered she said, 'You are not going to believe this!'" Together they said, "The exact same guy!"

Karen took over now. "That was right when we were waking up again."

Kathy said, "That was their signal that it was time for us to strengthen our gift, and we studied to be Reiki Masters and Interfaith Ministers. We delve into all things spiritual. Not religious. All the esoteric."

"So you are ministers and you studied to do this?"

"Yes," Kathy answered. "Karen has a master's in divinity."

"We do this to enhance our gifts and help those who may get stuck. It all fits together. We get signs. The right people seem to all come together at the right time."

"As it is happening now with us and with Nimham?"

They smiled.

"I'm not sure how much I can help with the signs, but I can help supply some of the history to answer some important questions."

Kathy interrupted me. "Troy Taylor, the paranormal I studied with, will tell you that you cannot have a proper investigation without the history of the subjects to back you up."

"Are you aware of Nimham's history at all?"

"No," they admitted.

I brought them up on the three phases of Nimham's life and they listened carefully. When I finished talking, Kathy said the magic words, "We need to go to that mountain together! Our meeting was meant to be. There is a story that needs to be told here. I'm so excited! We are being brought together for this purpose. Let's find him on that mountain."

"I would also like to bring the paranormal who saw Nimham up there. Can we do that?"

"That would be fine," Karen said, "but I know I need to go there. There is someone out there who will be helping us. I can't sense yet what he looks like but I am getting a feeling of great strength and courage. When someone like this comes into the world it is with a purpose and I think he was cut short. It has something to do with how Native Americans have been treated."

"Well, I think we need to set up going to the mountain together," I said. "We'll bring whomever we have to and go up the path to the fire tower at the top of the mountain and look for him. My guess is that we will feel his presence there."

"Yes. He's definitely there," they agreed.

"I feel the need to go there," Karen insisted. "We need to take some photos there and I can invite Buddy Banks. You must remember him from the George Denny investigation? He's a great psychic photographer and he's part Native American. I am feeling that Nimham is the guardian of the mountain, the caretaker."

Karen became very verbal. "I am hearing Nimham's message. It is about forgiveness and awareness. He does not want to hold anything against the people who did these things to him, but he wants this story told for his people. I see tears. There is a tremendous sadness surrounding him, but I hear forgiveness."

"Can we set this up for a Saturday morning?" I asked.

"We can. But I would also like to go to where his last battle was."

"Yes, we need to go there," Karen said. "I feel there is no question about going there together."

"Fine," I told her. "How soon can we go to the mountain?"

"Tell us," they answered. "We're ready when you are."

"Should we go next week?" I asked.

"Fine," they said. "Next Saturday."

INVESTIGATION AT NIMHAM MOUNTAIN: SATURDAY, DECEMBER 16

I met Kathy and Karen at approximately ten o'clock in the morning at the Nimham monument near the entrance to Nimham Fields County Park, formerly Putnam County Park. The five-foot stone with a bronze plaque was dedicated in a ceremony on June 15, 1996. The stone, the third monument to be dedicated to Nimham, was excavated from the battle area where Nimham died in 1778.

By 10:30, the team was ready to proceed. We parked at the base of a long path that wound up about one mile to the fire tower at the top of the mountain. I did my usual introduction for the tape by announcing the date and asking the participants to say their names: Brian Plogg; his girlfriend, Stephanie; Gil "Crying Hawk" Tarbox; myself; Karen Darby; Kathy O'Donnell Piccorelli; and Penny Osborne Tarbox all signed in.

Just to the right of us was an old bunker that had been used to store explosives years ago. Several members of the team headed straight for it. It resembled one of the many stone chambers sprinkled throughout the countryside. These chambers were reportedly haunted and Kathy had more than enough pictures to prove it.

"Do you feel anything?" I asked the sisters.

They both agreed that there was little to no energy coming from the cave-like opening. Penny joined them and offered some history on the bunker and some of the stone chambers in the area.

"There is a lot of speculation as to who built them," Penny was saying when I reached their group. "Some believe early Celtics built them, others believe they were built by Native Americans to store bodies in the winter, and still others say farmers built them as root cellars. This particular chamber is actually a bunker that was used to store explosives for mining. At one time you can see that there was a heavy metal door at the entrance."

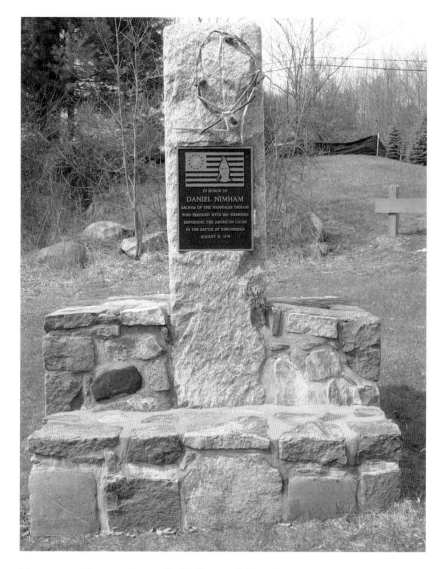

Monument at Putnam County Park. *Courtesy of the author.*

"So there are no spirits or energy in here?"

"No," they all agreed.

We left the bunker and our cars and continued the long journey to the top of the mountain. Along the way Gil reviewed some of Nimham's history.

"Nimham was here somewhere around 1758, when he came to visit. He actually left the area for Stockbridge in 1754 and lived there until

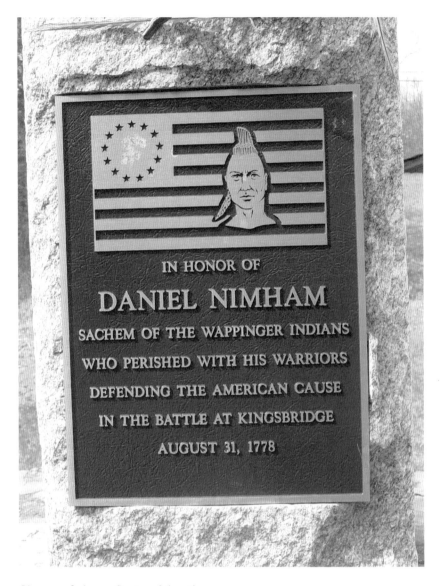

IN HONOR OF

DANIEL NIMHAM

SACHEM OF THE WAPPINGER INDIANS

WHO PERISHED WITH HIS WARRIORS

DEFENDING THE AMERICAN CAUSE

IN THE BATTLE AT KINGSBRIDGE

AUGUST 31, 1778

Close-up of plaque. *Courtesy of the author.*

the Revolutionary War. He kept coming back to fight the Philipse family and visit the few villages that were left."

"What about the mountains near Fishkill?" I asked.

"That was where their winter encampment was."

He stopped and pointed through the woods. "That's where one of the villages was," he said.

Bunker at Nimham Mountain. *Courtesy of the author.*

Stone chamber. *Courtesy of the author.*

Karen stopped to see if she could get any vibes, but she noticed a stone chamber to her right and walked to it. "This one has a bit of a vibe. They may have used this for storage but there is something else going on here." She walked over and knelt in the chamber and closed her eyes.

Kathy said, "Whoever built this put it here because of the energy in this spot."

"So the energy didn't come to this chamber, the chamber came to the energy?" I asked.

"I believe water ran through here. Water carries energy. I also feel that the energy here is not Native American." She turned to Gil. "Were there colonists here?"

Gil smiled and pointed to a spot a few feet from where we were. "The farm house was there," he said.

"Yes," she said.

I waited to hear more but she stood there seeming to meditate and I walked on to Brian.

"Can we talk while we walk?" I asked.

"Sure," he said.

INTERVIEW WITH BRIAN PLOGG AT NIMHAM MOUNTAIN

"So, your specialty is sound?"

"Yes. What I primarily do for an investigation is get a lay of the building or site to see who is there at the time. I record all of the sounds of the building like creaking floors, heating systems, doors squeaking, the people who are around the site and eventually the people I'm with. I check out their sounds such as the shoes they wear and the clothing they have; clothes make sounds. I need to know the sounds that can be picked up by my recorder that may be man-made. This way, later on, when I review the tapes and hear a noise, I can tell if it was something that was there or odd. I can determine if it is an EVP or a natural sound."

"What is an EVP?"

"Electronic voice phenomenon. Basically, it is sound that does not come in on a manmade frequency range. It's too low for the human ear and when you hear the voices and hear them loud and clear and run them through a program that detects human frequency, it is off the charts."

"How did you get involved in this? You are obviously a believer."

"It started when I was young. I saw spirits and as I got older I got involved with other people who were interested. The people who

are involved in the paranormal are the nicest people you will ever meet. They are open and sensitive. They are easy to work with on investigations."

"Going back to the investigations, I take it you have found evidence of paranormal activity."

"I listen to a lot of things I get and things other people get. I have pictures and EVPs that are clear. I've got pictures of apparitions with faces and whole bodies. Some of the voices I get are very clear."

"So there is no question that the supernatural does exist?"

"Yes. I believe that there is definite paranormal activity out there, but I am skeptical of certain places that people have investigated. I want to be sure of what I am seeing and hearing. I don't want to be doubted."

Brian continued to talk as we walked up the trail but then we were at the top of the mountain and the group started to get restless and noisy. Gil was giving another history lesson on Nimham and reminding us that this was the exact location where Nimham may have possibly visited annually. And then we were there.

The tower stood over us like some majestic giant. Members of the team began to spread out, following vibrations. Penny was facing the tower frozen to her spot. I approached her quietly and she addressed me without turning.

"That's the spot," she said. "It's where I saw him."

I turned to tell the others but they were gathered through the woods, taking photos or kneeling. I took several pictures and waited for Penny to say something, but she stood there not moving. I turned away from her and went to where Kathy and Karen were standing. Kathy was frustrated because her camera had stopped working.

"This is common during investigations. I hate when this happens," she said.

Soon we were all together again, ready to climb the 102 steps to the top of the tower. At the top I was out of breath from climbing and even more breathless at the view. The countryside was spread out before me and I felt that the sense of peace was surely what Nimham had come to experience all those years before me.

When I came down from the tower, I noticed that Karen had broken from the group and was standing with her back to us at the top of a knoll. I started to go to her but thought better of it. I stood on the path and waited. When she returned, she was disturbed.

"Was something there?" I asked

She spoke softly. "I was drawn to that spot. I felt strong vibrations coming from it. When I got there, I understood why." She stopped

talking and walked away from me and I wasn't sure of what to do. Should I follow her or go to the spot? I went to the spot. When I got there, it was as if I had been punched in the gut. The entire base of the knoll was covered in trash. Broken tires, bottles, baby carriages and debris had been dumped only feet from where Gil later told us that a village had been.

We walked down the long road to the parking lot, disappointed that no great manifestations had taken place. We all pretty much agreed that Nimham himself had not joined us. But we were far from discouraged.

"So," I asked the group, "When are we going to the park to find his grave?"

"I'm in," Karen said.

"Me too," Kathy echoed.

Soon, it was unanimous. We were going to Van Cortland Park in the Bronx to stand in the field where Chief Nimham and his son were killed. The date was set for Saturday, January 6, at ten o'clock. The investigation would begin at the monument set in the park on June 14, 1906.

VAN CORTLAND PARK, BRONX, NEW YORK
JANUARY 6, 2007

The plaque on the monument reads:

> *August 31, 1778*
> *Upon this field*
> *Chief Nimham*
> *Seventeen Stockbridge warriors*
> *As allies of the patriots,*
> *Gave their lives for liberty*
> *Erected by Bronx chapter*
> *Daughters of the American Revolution*
> *Mount Vernon, New York*
> *June 14, 1906*

I flipped on the tape and took roll: "Mike Keropian, Kathy O'Donnell Piccorelli, Buddy Banks, Vin Dacquino, Gil Tarbox, Penny Osborn Tarbox, Karen Darby, Jan Maline, Siobhan Trippodo."

After reading the monument aloud and taking a group shot we proceeded to a nature trail called the John Muir Nature Trail. Gil told us that it is one of the original roads from the 1700s. He pulled out

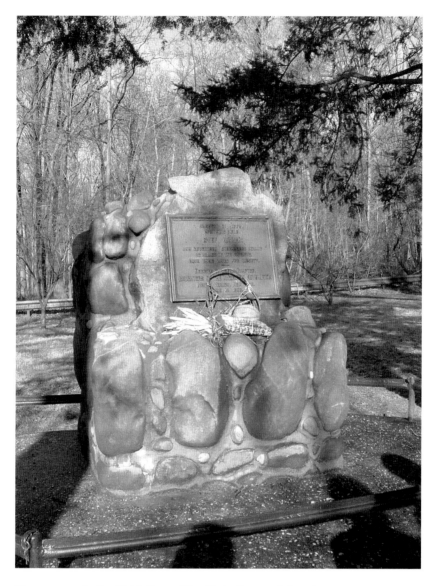

Monument at Indian Field, Bronx, New York. *Courtesy of the author.*

a map of the area from the time of the battle and showed the group how this trail leads to the battlefield. He showed us where Simcoe and Emerick came through and where Nimham's troops lined along the wall. We came out onto a paved road for a short way and then crossed onto a dirt path again that led to a swamp. It was here that the ambuscade occurred. Shortly before the attack the colonists that were

Investigation team: (from left to right) Michael Keropian, Jan Maline, Kathy O'Donnell, Buddy Banks, Vin Dacquino, Gil Tarbox, Penny Tarbox, Karen Darby. *Courtesy of Siobhan Trippodo.*

with him left. Nimham remained with his forty warriors. Karen stood and looked into the field.

"I feel some sort of river. Was there a river here?"

Penny answered, "It was here. It was rerouted years ago."

Karen continued to a spot by the edge of the marsh and asked, "Was there something wrong with his arm? I feel he is holding his arm."

"He was attacked by dogs and it was believed that they pretty much devoured him."

She pointed to three trees above us. "This is the trinity symbol," she said. "It is very significant for me. I kept asking him for a symbol, and I could see him lying by a tree. I couldn't see any tree of the size it needed to be to be old enough but then I saw this stump at the base of the three. My guess is that this is where he came down to and died."

"All of the signs are here," I said.

"Yes," she said. "The presence is very strong."

Kathy examined the fallen tree near the spot and noticed that it had grown around some kind of metal that was embedded in it. Buddy examined the pictures he had been taking and asked the group to make out the person in a headdress in one of the photos.

Gil and Penny playing the "Calling Out Song." *Courtesy of the author.*

The group stood now quietly on the spot where Daniel Nimham may have died. Gil and Penny walked to the top of the hill and took out their drum. They began playing the "Calling Out Song." It was the same song that Gil played when the spirit appeared to him at the fire tower in the photo earlier in this chapter. Karen, Kathy and Stephanie went into a meditative pose.

INVESTIGATIVE SUMMARY

The ultimate question, as it was in the George Denny case, is whether Chief Nimham is here in spirit. The answer according to all of the paranormals involved in the case is unquestionably yes. Did I actually see him? I have to answer no. Did I feel him and do I believe that he was with me at any time during the investigation? I have to answer yes. Chief Daniel Nimham, as was the case with George Denny, Sybil Ludington and the ghosts in Smalley Inn, has something to say that wasn't completely said when he was living. Daniel Nimham is trying desperately to let people know he can be heard.

Chief Daniel Nimham was a sachem for all men. His courage and dedication to his people is to be admired, but more importantly, he was a role model of a special sort. He defied the stereotypical chains that make men what they aren't. I am perhaps advantaged by my age when I think of "Indians," "Redmen" and "savages." I come from the era of Hollywood's cowboys and Indians. I was encouraged to visualize Native Americans as half-naked savages who couldn't read or write. The only thing they did well was kill white men. And so why wouldn't I be taken with a man like Daniel Nimham? He is a man who could not only read and write, but also defend himself in a courtroom where he didn't even have the right to vote. He didn't scalp the people who stole his lands. He didn't rape or kill their wives and daughters. He raised their neck hairs in different ways and fought them on their own turf, but still he lost. His people's land was taken from him, and despite his attempt to fight for it they took it from him in the end.

When he was told that the king of England was the only one who could help him, he refused to be intimidated. He went to England and lost his case there. Ultimately, he fought against the king. Side by side with his son he fought against the British as the American he was. In his final battle, his body and his land were desecrated.

I think of Daniel Nimham when I hear the words of Chief Seattle:

> *When the last Red Man shall have perished, and the memory of my tribe shall have become a myth among the white man, these shores will swarm with the invisible dead of my tribe, and when your children's children think themselves alone in the field, the store, the shop, or in the silence of the pathless woods, they will not be alone—At night when the streets of your cities and villages are silent and you think them deserted, they will throng with the returning hosts that once filled them and still love this beautiful land. The White Men will never be alone.*

Sybil Ludington
Spirit of Fire

Introduction

On the twenty-sixth day of April, 1777, sixteen-year-old Sybil Ludington sat by a fire with her parents in Fredericksburgh, New York. Seven siblings lay fast asleep as a cold, wet April wind beat against the sides of the Ludingtons' saltbox structure. It was a rare occasion when the colonel could escape from his the battles against the "Cowboys" and "Skinners," bandits who terrorized Westchester and Dutchess Counties, and enjoy the warmth of his family. In the distance, a lone rider rode hard toward them into the rainy night. His mission was to reach the colonel at all expense and urge him to rouse his four hundred men. Behind the messenger, Danbury, Connecticut, was under siege of the British under the command of Major General William Tryon, former royal governor of the colony of New York. Word had reached the commander that patriot supplies had been stored on Connecticut soil. Tryon gathered two thousand troops and set out to destroy the munitions. Citizens were killed and houses were set on fire. One report from British General Howe stated that the village was unavoidably burnt and the munitions destroyed were of great quantity. American spirit was being challenged to bear arms against the enemy in a revolution against injustice, and Sybil Ludington, who had turned sixteen only three weeks before her ride, rose to the cause.

When I decided to include Sybil in *Hauntings of the Hudson River Valley* I refrained from calling in my paranormal teams to assist me. It wasn't that I didn't believe her spirit was alive; there is no question in my mind that the spirit of Sybil Ludington is very much alive and has very much been the inspiration for my investigations into her life. She has literally haunted me for the last ten years, and will continue to do so

until her mission is complete. The addition of this chapter in the book is because Sybil is haunting the Hudson River Valley, as may be the case with George Denny and the ghosts of Smalley Inn, and because she is a strong spirit with a past history that demands correcting, and/or a message that needs delivering.

In 1997, I began a research investigation that unearthed one of the greatest mysteries in the history of the Hudson River Valley to date. I was to find out that teachers and historians had gotten it wrong when it came to Sybil Ludington's life after her ride. They had her achievement on April 26 down pretty well, but they flubbed the rest of her life. Local groups, such as the Enoch Crosby Chapter of the Daughters of the American Revolution, rallied behind her and literally put Sybil on a pedestal. They dedicated a statue, road markers, a postage stamp, poems, songs, operas and plays to her. Locals still conduct "Sybil Ludington Day" in her honor and invite people from faraway places to come and pay tribute to the hero of Putnam and Dutchess Counties. But she went virtually unrecognized for her deed for over 130 years, and when it went beyond the night of her ride, historians could barely squeak out a paragraph about the hero for another 90 years. What they did come up with was mostly unfounded and undocumented:

> *After her famous ride, Sybil Ludington lived to be seventy-seven years old. She married her childhood sweetheart, Edmond* [or Edward, or Henry; the first name varied with the article] *Ogden, who was a lawyer in Catskill, New York. Sybil bore six children: four boys and two girls. One of her children was a hero in Kansas. The family later moved to Unadilla, where Sybil died on February 26, 1839.*

Since the 1930s, this paragraph, or variations thereof, has been repeated in article after article, though the facts remain unsubstantiated. I endeavored to uncover the truth, if any, that it held.

SYBIL'S RIDE

Before getting too involved in Sybil's life after the ride, I knew I had to be clear on what exactly happened on the night of April 26, 1777. The best way to do that was to take the story to its roots. Details, or what we have of the details, came to the public eye in 1907 in two ways. Lewis (also called Louis) S. Patrick, a historian and Ludington descendent, released an article early in 1907 in *Connecticut Magazine* titled "Life of Colonel Henry Ludington of Connecticut–Born 1739: Secret Service

of the American Revolution." Information on the ride was sparse, but it was the first release.

> *The expedition, consisting of two thousand men, sent out to destroy stores and munitions of war collected at Danbury, Connecticut under the command of General Tryon, reached that place Saturday, April twenty-six, 1777. The guard, too small for protection, and too weak for effective resistance, withdrew. Preperations were immediately made to harass the enemy. A messenger was dispatched to Colonel Ludington to summon him in the defense of the place. He arrived in the evening of that day. The members of Colonel Ludington's regiment were at their homes which were miles apart and scattered over a wide territory. To summon them was no easy task. There was no one ready to do it. Sibbell, the young daughter of Colonel Ludington, a girl of sixteen, volunteered to do this service. She mounted her horse, equipped with a man's saddle (some members of the family say without saddle or bridle), and galloped off on the road in the dead of night to perform this courageous service. The next morning by breakfast time, the regiment had taken up the line of march and was in rapid motion towards Danbury, twenty miles distant.*

Willis Fletcher Johnson was the second author/historian to mention Sybil's ride. His account contributed new information but was still rather sparse:

> *At eight or nine o'clock that evening a jaded horseman reached Colonel Ludington's home with the news…But what to do? His regiment was disbanded; its members scattered at their homes, many at considerable distances.* [It was April, planting season, and the farmers needed to tend their fields and had been granted leaves to get their work done.] *He must stay there to muster all who came in. The messenger from Danbury could ride no more, and there was no neighbor within call. In this emergency he turned to his daughter Sybil, who, a few days before, had passed her sixteenth birthday, and bade her to take a horse, ride for the men, and tell them to be at his house by daybreak. One who even rides now from Carmel to Cold Spring will find rugged and dangerous roads, with lonely stretches… But the child performed her task…as she rode through the night, bearing the news of the sack of Danbury… By daybreak, thanks to her daring, nearly the whole regiment was mustered before her father's house at Fredricksburgh, and an hour or two later was on the march for*

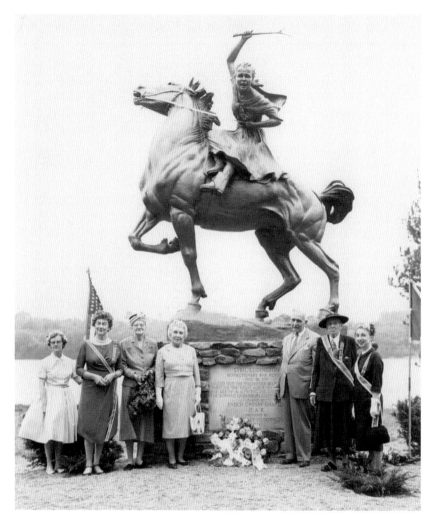

Dedication at Lake Gleneida. *Courtesy of Putnam County Historian's Office.*

vengeance on the raiders…That night they reached Redding, and joined Arnold, Wooster, and Silliman. The next morning they encountered the British at Ridgefield…and made [the British] retreat to their ships at Compo resemble a rout…Arnold had his horse shot from under him as, almost alone, he furiously charged the enemy, and the gallant Wooster received a wound from which he died a few days later. There were far greater operations in the war than this, but there was scarcely one more expeditious, intrepid and successful.

By 1935, word of Sybil's ride was out and the Daughters of the American Revolution aided in assigning road markers along Sybil's route. Her ride took on new dimensions in the retelling of the ride in countless newspaper and magazine articles. Perhaps the best rendition of her ride came in a poem by the celebrated American poet, Berton Braley.

Sybil Ludington's Ride

Listen, my children, and you shall hear
Of a lovely feminine Paul Revere
Who rode an equally famous ride
Through a different part of the countryside,
Where Sybil Ludington's name recalls
A ride as daring as that of Paul's.
In April, Seventeen Seventy-Seven,
A smoky glow in the eastern heaven
(A fiery herald of war and slaughter)
Came to the eyes of the Colonel's daughter.
"Danbury's burning," she cried aloud.
The Colonel answered, "'Tis but a cloud,
A cloud reflecting the campfires' red,
So hush you, Sybil, and go to bed."

"I hear the sound of the cannon drumming"
"'Tis only the wind in the treetops humming!
So go to bed, as a young lass ought,
And give the matter no further thought."
Young Sybil sighed as she turned to go,
"Still, Danbury's burning—that I know.
Sound of a horseman riding hard
Clatter of hoofs in the manoryard…
Feet on the steps and a knock resounding
As a fist struck wood with a mighty pounding."
The door's flung open, a voice is heard,
"Danbury's burning—I rode with word;
Fully half of the town is gone
And the British—the British are coming on.
Send a messenger, get our men!"
His message finished the horseman then
Staggered wearily to a chair
And fell exhausted in slumber there.
The Colonel muttered, "And who, my friend,
Is the messenger I can send?

Your strength is spent and you cannot ride
And, then, you know not the countryside;
I cannot go for my duty's clear;
When my men come in they must find me here;
There's devil a man on the place tonight
To warn my troopers to come—and fight.
Then, who is my messenger to be?"
Said Sybil Ludington, "You have me."

"You!" said the Colonel, and grimly smiled,
"You! My daughter, you're just a child!"
"Child!" cried Sybil. "Why I'm sixteen!
My mind's alert and my senses keen,
I know where the trails and the roadways are
And I can gallop as fast and far
As any masculine rider can
You want a messenger? I'm your man!"

The Colonel's heart was aglow with pride.
"Spoke like a soldier. Ride, girl, ride.
Ride like the devil; ride like sin;
Summon my slumbering troopers in.
I know when duty is to be done
That I can depend on a Ludington!"

So over the trails to the towns and farms
Sybil delivered the call to arms
Riding swiftly without a stop
Except to rap with a riding crop

On the soldiers' doors, with a sharp tattoo
And a high-pitched feminine halloo.
"Up! Up there, soldier. You're needed, come!
The British are marching!" and then the drum
Of her horse's feet as she rode apace
To bring more men to the meeting place.

Sybil grew weary and faint and drowsing,
Her limbs were aching, but still she rode

Until she finished her task of rousing
Each sleeping soldier from his abode.
Showing her father, by work well done,
That he could depend on a Ludington.

96

Dawn in the skies with its tints of pearl
And the lass who rode in a soldier's stead
Turned home, only a tired girl
Thinking of breakfast and then of bed
With never a dream that her ride would be
A glorious legend of history;
Nor that posterity's hand would mark
Each trail she rode through the inky dark,
Each path to figure in song and story
As a splendid, glamorous path of glory—
To prove, as long as the ages run,
That "You can depend on a Ludington."

Such is the legend of Sybil's ride
To summon the men from the countryside,
A true tale, making her title clear
As a lovely feminine Paul Revere!

THE CARDBOARD BOX

I again began my research with a cardboard box and a whole lot of unanswered questions. The first step of the investigation involved gathering everything immediately available, including newspaper articles, magazine clippings, history book passages and local folk tales. Librarians and historians had the most to offer and from the start there were contradictions in Sybil's story. To begin with, no one seemed sure of her husband's name. In William Pelletreau's *History of Putnam County*, her husband was listed as "Henry Ogden." He was again called "Henry" in J.H. Beers's *Commemorative Biographical Record: Dutchess and Putnam County, NY*. In Willis Fletcher Johnson's *Colonel Henry Ludington: A Memoir*, her husband was listed as "Edward (the name elsewhere given as Edmund or Henry)" and later in the same book as "Henry (elsewhere called Edward or Edmund)."

THE CEMETERY

The breakthrough on Sybil's husband came at the Maple Avenue Cemetery in Patterson, New York. She is buried there alongside her mother and father. On my first visit I had no idea where in the cemetery she was buried. I knew she was in there from the marker placed in front of the church and a historical marker recounting the history of the church.

I went into a little deli located in a small shopping center next door to the cemetery. I was sure they would know where Sybil had been buried. I addressed a young man behind the counter, "Excuse me, I'm trying to find Sybil Ludington's grave," I said.

He looked at me incredulously. "Wow," he said. "She died? I didn't even know she was sick."

It was my turn to be incredulous. "She died in 1839," I said.

"Oh," he answered. "No wonder I didn't hear about it. Do you want to buy anything?"

I bought a pack of mints and after a lot of searching found the Ludington graves behind the left corner of the church. My answer to the Edmund/Edward/Henry puzzle was clearly engraved on the marker. Pelletreau, Beers and Johnson had all been wrong. She was the wife of Edmond Ogden; not Edmund, Henry or Edward.

Although I was pleased with my new information, I was puzzled as I stood before Sybil's grave. Where were her six children? Could it be that none of them were buried with her? And where was Edmond? I was also puzzled by the spelling of her first name. I was to later find out that, like her husband's, there were multiple spellings of her name recorded.

I read each stone in the cemetery in search of Sybil's family, though it dawned on me that even if I did find any Ogdens, I didn't know the names of her six children. My cardboard box was starting to get full. I had copied every article I could copy and taken notes on the rest. There were no mentions of Sybil's children. I could find no birth records, school records, marriage or death records. None of the historians had any mention of the Ludington-Ogden children in their books. I even contacted some of the Ludington descendants—no one could give me the names of the "six children" that Sybil "bore."

RESEARCH IN CATSKILL

My next guess was that I would find some answers in Catskill, New York. The question was, if Sybil had lived there, where exactly had she lived? I hit the local library and started digging until an idea hit me. Who leaves better paper trails than a lawyer? I was sure to find old legal cases at the county clerk's office. I spent hours searching through their files. There were cases involving Ogdens, but none defended by Edmond Ogden, attorney at law. In fact, there were no legal records at all involving any Edmond Ogden. If he had been a lawyer there, he had to have been a starving one.

My time in Catskill, however, was not wasted. A historian by the name of Mabel Parker Smith also appeared to have been interested in Sybil Ludington Ogden. She wrote a series of articles in the Catskill *Daily Mail*, titled "Unsung Heroine of Revolution Became Inn-Keeper on Busy Main Street Corner in Early Catskill."

The Mabel Parker Smith Articles

Finding the four articles written by the Greene County historian from January 9, 1978, through January 12, 1978, was like finding gold. Most interesting about this series of articles was that it did not so much provide answers, it confirmed my questions. Passages from the articles are printed here in part as they appeared in the *Daily Mail*:

> *Part I*
> *Did Greene County entertain a heroine unawares two hundred years ago? Or wasn't Sybil Ludington a heroine in her own time?*
>
> *When Putnam County celebrated last Spring the bicentennial of the midnight ride of its female Paul Revere, was it long overdue tribute to an American victim of male chauvinism? And was it still man's notion of woman's role which continued to ignore her youthful service when, a mature woman, she took her place in a man's world in Catskill?*
>
> *There is no hint of recognition of her earlier heroism after Sybil Ludington came to Catskill with her husband, Edmund* [note the incorrect spelling of Edmond] *Ogden, sometime after their marriage in 1784. Ogden is believed to have been a lawyer. That he lived in Catskill for several years, was a substantial member of the community, and died early, there is ample evidence. Just when and where he died and where he is buried are details which still elude researchers in at least three concerned counties, Putnam, Greene, and Delaware.*
>
> *As a widow, mother of six children, Sybil Ogden had the means, and the enterprise, to acquire a desirable business location at "The Landing" (Catskill) very early in the 19th century and to establish herself in one of the few means of livelihood then open to a woman able to make some capital investment. Her name appears first, and the only woman, among twenty-four inn-keepers listed in Catskill and vicinity in 1803.*

The article sent my head spinning. It confirmed Sybil's time in Catskill and her marriage to Edmond Ogden. It provided her wedding year and spoke of her husband's early demise. In 1978, less than twenty years from the beginning of my research and two hundred years after her ride,

there were still more questions about Sybil's life than there were answers. What was most peculiar was the mention of Sybil's six children. Did this single mother really run a tavern in a busy location in Catskill, New York, while she raised six children? I ran to the county clerk's office to get a copy of the deed. It was dated "the second day of May in the year of our Lord one thousand eight hundred & four BETWEEN Reuben Webster of the County of Litchfield and State of Connecticut of the one part and Sibil Ogden Widow of the Town of Catskill County of Greene and State of New York of the other part—"

Part I of Smith's article continued to talk about Sybil. She cited some resources and talked about Sybil's ride and the various celebrations in Putnam County. Part II was printed only one day after Part I, on September 10, 1978.

In 1784, at 23, Sybil Ludington married Edmond Ogden, also of Fredericktown Precinct, and they were still there in the1790 Census. By 1793 they were well settled in Catskill at a time when the sparse community at The Landing was enjoying rapid growth and fast coalescing into a bustling river port and commercial center.

The article went on to discuss Catskill during the time period and I sat analyzing what I had learned. If Sybil had married Edmond Ogden when she was twenty-three, she sure took a long time to marry her "childhood sweetheart." I went to do a little record searching in Dutchess County. If Sybil and Edmond were childhood sweethearts, they had to have been neighbors. The first place to look was in local maps and census records in Fredericksburgh. The Ogdens were there. Edmond's father was Humphrey Ogden and his mother was Hannah. They did live near Sybil, but not until the early 1780s. A deed also showed "Edmond Ogden and wife Sybil" selling property in Fredericksburgh in 1793, the year that they contributed to the building of a school in Catskill.

THE FREDERICKSBURGH DEED

There are no records of the Ogdens buying property in their early years in Catskill, but according to Mabel Parker Smith and Greene County records, they did donate money to the building of a school.

That was the Catskill community in 1793 when Edmond Ogden signed among fifty-seven public-spirited, presumably well-to-do,

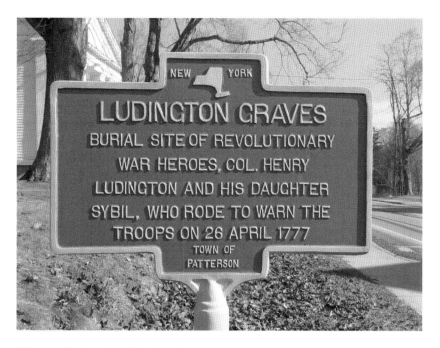

Marker at Presbyterian Church in Patterson, New York. *Courtesy of the author.*

Courtesy of the author.

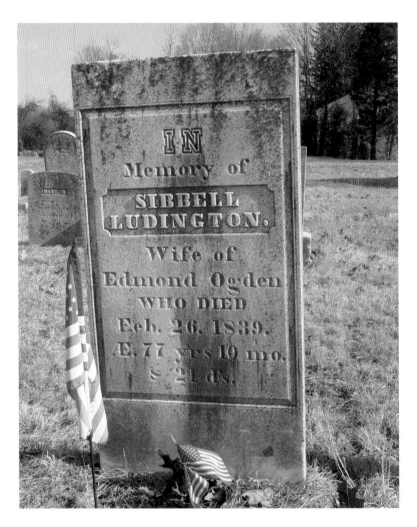

Sybil's gravestone. *Courtesy of the author.*

citizens who took up one hundred shares at four pounds each "to have an academy erected at the Landing in said town of Catskill." Ogden subscribed to two shares, which put him in the top half of supporters. In 1795, when additional funds were needed to complete the school, Ogden signed on again for two more shares, on a thin list of twenty-four supporters.

After all, Ogden, a man of more than ordinary education himself, had six children to educate. That he was not able to see it through was evident. That academy subscription in 1795 is the last known of him alive. By 1803, perhaps before 1800, Sybil was a widow, in business

for herself in Catskill, with two sons and four daughters, none beyond their teens. She was still demonstrating courage in crises.

If Edmund died at Catskill or vicinity before 1800, papers in his estate, either Will or Letters of Administration, should be found in Albany County surrogate's records. Recent search of those records, by this historian [Mabel Parker Smith] has yielded nothing whatever in the name of Edmund Ogden (or any other in the family) in Albany County before 1800, nor do Greene County records yield any clue after 1800. The chief mystery remains. When and where did Edmund Ogden die and where is he buried?

The Mabel Parker Smith articles left me thinking for weeks. Where had previous researchers looked? Why wasn't anyone able to find the rest of Sybil's family? Why was she buried without them? One researcher speculated that there was a slim possibility that Edmond Ogden, and possibly his wife and family, had moved on to another rapidly developing frontier at Unadilla, Delaware County, on the Susquehanna River, and that he might have died there. However, no trace of him has ever been found there in long and exhaustive searches by researchers. The fact that Sybil later moved to Unadilla with her family was consistent with the ubiquitous paragraph, but not consistent with the possible dates of Edmond's death and Sybil's purchase of the tavern.

Part III of Smith's article, of Wednesday, January 11, 1978, added more confusion to my investigative fires.

Time and place of her husband's demise now a mystery, it would nevertheless appear that the Widow Ogden, in her early forties, with two sons and three daughters established herself in business to finish raising her family in Catskill before retiring to her elder son's home at Unadilla probably after 1810, when she sold her Catskill property.

Part IV, the final article in Smith's series, sent me searching through the Catskill libraries and research centers.

Whenever the unsung Revolutionary War heroine departed Catskill and wherever she spent her latter days, very probably back in her native Dutchess-Putnam locale, since she is buried there, some of the six Ogden children may have remained in Catskill.

I left the articles and Catskill somewhat disappointed, but not discouraged. I "simply" had to comb the Catskill area for the lost children. My search was fruitless. I was sure I was onto one of the

THIS INDENTURE made the second day of May in the year of our Lord one thousand eight hundred & four BETWEEN Reuben Webster of the County of Litchfield and State of Connecticut of the one part and Sibil Ogden Widow of the Town of Catskill County of Greene and State of New York of the other part WITNESSETH That the said Reuben Webster for and in consideration of the sum of Seven hundred & thirty two dollars lawful money of the State of New York to him in hand paid at or before the ensealing and delivery of these presents by the said Sibil Ogden the receipt whereof is hereby confessed and acknowledged Has granted bargained sold aliened remised released & conveyed assured enfeoffed and confirmed and by these presents Doth fully freely and absolutely grant bargain sell alien remise release convey assure enfeoff and confirm unto the said Sibel Ogden her heirs & assigns forever All that certain piece or parcel of Land situate in the Town of Catskill County of Greene and State of New York at the Catskill Landing on the west side of the Main Street leading through said Landing Beginning at the South East corner of Joseph Grahams Lot or the Lot by him occupied Thence running South Eleven Degrees forty five minutes East seventy seven feet two Inches to the intersection of the Street leading to the Catskill Creek Thence running down the north side of said Street South Sixty three degrees west fifty two feet to the South East corner of the house lately occupied by Thomas O H Croswell Thence north Twenty seven Degrees west Thirty seven feet. Thence running south Sixty three degrees West twenty four feet to the line of John Dubois's Lot North Eleven degrees forty five minutes West forty three feet or to Joseph Graham's Lot Thence north Sixty five Degrees East Eighty five feet to the place of Beginning Also Lot known as Lot Number Twelve in the subdivision of Lot number Two in Linseys Patent Beginning at the south east corner of Lot number Eleven Thence south Eleven degrees and forty five minutes East fifty two feet Thence South Seventy eight Degrees fifteen minutes East to Lot Number Thirty Thence north Eleven degrees forty five minutes West fifty two feet thence westerly to the place of Beginning Together with all and singular the appurtenances privileges and advantages whatsoever unto the said above mentioned and described

Deed for Sybil's property in Catskill, New York. *Courtesy of Greene County Clerk's Office.*

greatest mystery investigations in the history of New York. I went back to the paragraph that had been repeated in article after article since the 1930s to review what I had.

Breakthrough in Yorktown

After nearly a year and a half of researching, a new breakthrough occurred. I went to visit the Yorktown Family History Center, Church of the Latter Day Saints, Yorktown Heights, New York. I used their IGA North America Family Series to search for genealogical information on the Ludington and Ogden families. When I plugged in Edmond Ogden, an interesting thing occurred. Information for Edmond Ogden came up with more information than I had dreamed of. His parents were listed as Hannah Bennett and Humphrey Ogden of Westport, Connecticut. They married at Westport, November 22, 1743. They had eleven children. Edmond was listed as their sixth child.

> *Edmond—b 2/12/1755, baptized 3/2, died in New York State 9/16/99; married at Patterson, Putnam County, New York 24, October. 1784 (Pension rec.), Sybil_____, * who was living 1838 Unadilla, Otsego County, NY.*

> *Her sister Mary was wife of Rev. Ashahel Gilbert of Poughkeepsie, NY

I stared at the information in total disbelief and then ran up to the information desk. "Where did this information come from?" I asked.

"We can look it up if you would like," she said.

"You mean you can do it now?" I asked.

"Yes," she said. Within minutes I was thumbing through the phone book looking up a man named Edward Lanyon Woodyard, whose research was about to crack open my entire investigation. I called him.

"I'd like to speak with you about your research on the Ludingtons," I said.

"I didn't research the Ludingtons," he answered.

"But I have your research here at the Church of Latter Day Saints," I explained. "She married Edmond Ogden."

"Ogden?' he said. "I did do research on the Ogdens."

He was less than fifteen miles from where I stood and offered to let me see his research right then if I liked. Since Sybil's last name was never mentioned, he hadn't realized what a great find he had made.

THIS INDENTURE made the twenty third day of April one thousand seven hun-
dred and ninety three between EDMOND OGDEN of Fredericks town and County of
Dutchess and state of New York farmer and SYBIL his wife of the first part and
SAMUEL AUGUSTES BARKER of Fredericks town aforesaid farmer of the second part
witnesseth that the said EDMOND OGDEN and SYBIL his wife for and in consideration
of the sum of four hundred and eighty pounds money of the said State to them in
hand paid by the said BARKER have and each of them hath granted bargained sold
alliened enfeoffed and confirmed and by these do and each of them doth grant bar-
gain sell alien enfeoff and confirm unto the said BARKER and to his heirs and
assigns forever ALL that certain tract or parcel of Land scituate lying and being
in Frederickstown aforesaid being parcell of a farm of one hundred and seventy
three Acres conveyed to BENJAMIN BIRDSALL and HENRY LUDENTON by SAMUEL DODGE
and JOHN HATHORN Commissioners of forfeitures for the middle district and Lately
released

to

Sybil's and Edmond's Fredericksburgh deed. *Courtesy of Dutchess County Clerk's Office.*

The real key to his research was "(Pension rec)," written in parenthesis. In Mr. Woodyard's notes, it said pension records had been referenced from several volumes of Donald Lines Jacobus's *History and Genealogy of the Families of Old Fairfield*. He explained that Sybil was evidently a widow and had applied for a pension for her husband's service in the military. She would have to write specific letters and depositions proving that she was entitled to the pension. I asked how I could find these pension records; Mr. Woodyard suggested I try the National Archives in Washington, D.C. When I called them they suggested I try the National Archives in New York City, on the twelfth floor at 201 Varick Street.

My first step was to get my hands on the Jacobus books. I found them at the Greenwich Library in Connecticut. The information was in two separate volumes: *History and Genealogy of the Families of Old Fairfield Volume II, Part 23, 1932* and *History and Genealogy of the Families of Old Fairfield, Volume III.*

Volume I was where Edward Lanyon Woodyard had gotten his information. Aside from a few commas, colons and periods, it was the same. Volume III, however, had me yelling across the library. It not only referred to the pension records, it summed them up and gave the reference numbers of where to find them.

THE OGDEN FILES

Ogden, Edmond
Pension Files, R 7777, Sibal, widow of Edmond
 Otsego County, N.Y., 8 Sept. 1838. Sibal Ogden, of Unadilla, aged 77 yrs. last Apr., widow of Edmond Ogden, a Sergt. In the Revolutionary army, who served also in the Navy, deposed. He died 16 Sept. 1799. They were married 24 Oct. 1784. Service: He enlisted at Weston, Fairfield County, Apr. 1776, as Sergt. In Capt. Albert Chapman's Co., Col. Elmore's Regt., and served to Apr. 1777. Was at German Flatts, Fort Dayton, Stanwick, and elsewhere. She does not remember clearly, but thinks Edmond served 6 to 8 mos. In 1778, near Boston. He also served at sea, on board several vessels, commissioned by Congress, and particularly under the command of Paul Jones in the "Bony Richard" [sic] and other vessels. Her husband returned from France dressed in French clothing, and related where he had been and his service in Commander Jones' "hottest battles." She received letters from him, and had in her possession one he had written to his father, enclosing the discharge from one of the vessels, as Sergt. of Marines.
 Julia Ogden of Unadilla, aged 49 yrs., daughter-in-law of Sibal Ogden. They have lived in the same house together about 30 years. Had seen letters and papers, including the discharge.
 23 Aug. 1838. Fanton Beers of Weston, aged 82 yrs. Enlisted 15 Apr. 1776 for 12 mos. Edmond Ogden also enlisted and they went to Albany, to German Flatts, etc. We were school boys together and very intimate until his removal to New York.
 Mary Gilbert of Poughkeepsie, wife of Rev. Asahel Gilbert, only surviving sister of Sibal Ogden. She was present at the marriage of said Sibal Ogden, her sister, with the said Edmond Ogden, Rev. Ebenezer Coles, Baptist clergyman, at Patterson, Dutchess County, now Putnam. Edmond died of yellow fever in New York City many years ago, but after 1800.

I was mesmerized by the amount of information on Sybil and Edmond. My goal now was to find the files in the National Archives to substantiate all that Jacobus had printed with primary documents. I made it down to Varick Street as quickly as I could. Sybil's file sat there in microfilm like unburied treasure. The file, a collection of letters, contained a signed deposition by Sybil:

 —the Widow *Cybal* [crossed out and respelled Sebal] *a resident of the Town of Unadilla in Otsego County and State of New York*

aged seventy-seven years last April who being particularly sworn according to Law doth on her oath make the following Declaration in order to obtain the Benefit of the provision made by the Act of Congress passed the 4th day of July 1836. And also of the late Act of Congress passed for the Benefit of Certain Widows and for other purposes.

Sybil's letter continued with a comprehensive review of her husband's service in the military as was summarized by Jacobus. Most notable was that Edmond enlisted from Connecticut in 1776, confirming the fact that he was not a native New Yorker and not likely a "childhood sweetheart" of Sybil.

Sybil's letter was dated the fourth day of September 1838. The second letter was from Sybil's sister, Mary Gilbert, wife of Reverend Asahel Gilbert:

Mary Gilbert of the Town of Poughkeepsie in Said County, wife of the Rev. Asahel Gilbert being duly Sworn deposes and says that she is personally acquainted with Sibal Ogden, now a resident of the Town of Unadilla, County of Otsego is Said Widow relict of Our Edmond Ogden deceased, a revolutionary Officer who served in the naval department of the United States of America under command of John Paul Jones—that the deponent is a sister of the said Sebal Ogden and the only sister surviving; that the deponent was personally present at the marriage of the said Sibal, her said sister with the said Edmund Ogden which marriage was solemnized before the expiration of the Revolutionary War and several years previous to the first day of January in the year of Our Lord One thousand seven hundred and ninety four by the Reverend Ebenezer Cole a legally ordained and esteemed Clergyman of the Baptist Connection.

And the deponent further states that said marriage occurred in the Town of Patterson in the County of Dutchess, now Putnam in the state of New York—and further that the said Sibal Ogden widow as aforesaid of said Edmund Ogden is and has remained a widow ever since the death of the said Edmund who died of the yellow fever in the City of New York many years ago about the year 1800 but in what precise year the deponent knows not.

And further that the said Sebal is aged and in precarious health.

The letter was dated the twenty-first day of August, 1938. The value of this letter was in the specific mention of how and where Edmond Ogden

died. The only glitch in the letter was in Mary Gilbert's testament to the date of the wedding; she missed it by exactly ten years.

A third letter helped to document Edmond's participation in the service and his growing up in Connecticut. The letter was the deposition of Edmond's childhood companion Fanton Beers:

> *I was a Soldier in the War of the Revolution. That on the fifteenth day of April 1776 I enlisted for twelve months in a company of I think Connecticut State Troops under the Command of Albert Chapman of Fairfield Town and County and State aforesaid as Capt. In Col. Elmore's regiment and Marched with said company to Albany where we joined the Regiment. The Regiment then marched to the German Flatts as called when we built the fort called Fort Dayton. We then marched to Fort Stanwicks where we relieved a Massachussetts Regiment and we continued and finished the fort by them begun and continued at said fort under the command of said officers until the 18th day of April 1777 at which time the regiment was discharged making my time of service one year and three days—I well remember Edmond Ogden then of said town and county of Fairfield and State of Aforesaid Enlisting with me into said company under said Chapman in Said Col. Elmore's Regiment and went to Albany with me from there to Fort Stanwicks and continued there with Said company for the full term of one year and three days and was discharged when I was. The Said Ogden enlisted and served as Sergeant of said company the whole term aforesaid. He and I were schholl boys and always very intimate until he moved into the state of New York.*

Fanton Beers's letter confirmed Edmond's residence as a boy in Connecticut right up to his enlistment in 1776. According to Jacobus's birth entry for Edmond, Edmond was twenty-one at the time.

A fourth letter helped me to complete Sybil's life from birth to death and dismissed Mabel Parker Smith's theory that Sybil had "returned to her native Putnam/Dutchess County after her Catskill days." In her letter, Julia Peck Ogden deposed that

> *she the said Julia is daughter-in-law to the said Cybal* [crossed out and changed to Sebal] *Ogden, that they have lived in the same house together about thirty years past. That she knows the said Sebal to have been the wife of Edmond Ogden who served in the War of the Revolution (as she is informed and believes to be true) that she has seen letters and an old paper purporting to be a discharge some years ago which she thinks*

Deposition letter signed by Sybil. *Courtesy of the National Archives.*

are lost—*that she well knows that said Sebal Ogden is the identical same person who was the wife and is now the widow of the said Edmond Ogden who died of the yellow fever in the month of September 1799—that she remained a widow and is now the widow of the said Edmond Ogden.*

The letter bore Julia's signature and gave second document to Edmond's death date and cause of death. It further confirmed the last thirty years of Sybil's life before her death on February 26, 1839, just over six months after Julia's deposition. Most interesting was the response to these letters.

Though Sybil proved beyond a doubt that she was the wife of a veteran of the Revolutionary War, she was denied, "on the ground of insufficient proof of marriage."

Sybil died less than six months after the date of her rejection. Her body was taken back to Patterson, where she had been married, and was buried next to her parents.

JANET WETHY FOLEY

My final remaining mystery and suspicions were confirmed by Janet Wethy Foley in a passage about Henry Ludington, Sybil's father, in her *Early Settlers of New York: Their Ancestors and Descendents Volume II, 1934.*

> *Sybil Ludington had but one child, Henry Ogden, and one of her grandsons, Major Edmond Ogden, a distinguished officer of the U.S. Army, died at Fort Riley, Aug. 3, 1855 of cholera. Statements contrary to the above have since been found to be incorrect.*

It is unfortunate that Janet Wethy Foley is not around to explain how she figured this out. In any case, few people apparently read her passage about Sybil. From the 1930s to the 1990s, writers insisted on giving Sybil credit for giving birth to six children. I studied Foley's theory and

Mary Gilbert of the Town of Poughkeepsie in said County, Wife of the Rev. Asahel Gilbert, being duly sworn, deposes & says; that she is personally acquainted with Sebal Ogden, now a resident of the Town of Unadilla County of Otsego in said Widow, relict of One Edmund Ogden deceased, a revolutionary Officer, who served in the Naval department of the United States of America under Commodore John Paul Jones;- that this deponent is a sister of the said Sebal Ogden, & the only sister surviving;- that this deponent was personally present at the marriage of the said Sebal Ogden, her said sister, with the said Edmund Ogden which marriage was solemnized before the expiration of the Revolutionary War, & several years previous to the first day of January in the year of Our Lord One thousand Seven hundred & Ninety four;- by the Reverend Ebenezer Coles a regularly ordained & esteemed Clergyman of the Baptist Connection.

And this deponent further says that said marriage occurred in the Town of Patterson, in the then County of Dutchess, now Putnam, in the State of New York And further that the said Sebal Ogden widow as aforesaid of said Edmund Ogden is, & has remained a widow ever since the death of the said Edmund, who died of the Yellow Fever in the City of New York many years ago, since the year 1800, but in what precise year this deponent knows not. And further that the said Sebal is aged, indigent & in very precarious health— Further this deponent saith not.

Subscribed & Sworn this
21st day August
A.D. 1838. Before me
Silas E Haight
Justice of the Peace in and
for Dutchess County —

Mary X Gilbert
her mark

State of New York ss
Dutchess County This may

Mary Gilbert's deposition letter. *Courtesy of the National Archives.*

then it hit me. Suppose Sybil's only child was Henry? Wasn't Henry the name that Pelletreau and Beers used for Sybil's husband? What would I find if I researched Henry Ogden?

Edmund Augustus Ogden

Edmund, a grandson of Sybil Ludington, was a graduate of west point military Academy. At 44 years old, in 1855, Edmund Augustus lost his life helping women and children stricken by Cholera in a place called Fort Riley, Kansas. A monument was built in his honor.

What I found, of course, was the answer to my mystery. Foley was right. Henry was a lawyer in Catskill, New York. He was the father of six children: four boys and two girls. He practiced law in Catskill and then moved to Unadilla with his family. One of his sons, Edmund Augustus Ogden, was a hero in Fort Riley Kansas. Pelletreau and Beers had switched Henry's name with his father's, throwing researchers off for years. When it was finally realized that her husband's name was Edmond, and not Henry, people stopped calling her husband Henry, but continued to associate all of Henry's biographical information to Sybil.

CORRECTING THE PARAGRAPH

After her famous ride, Sybil Ludington lived to be seventy-seven years old. True. According to her gravestone, she lived to be seventy-seven years, ten months, and twenty-one days. *She married her childhood sweetheart, Edmond* [or Edward, or Henry; the first name varied with the article] *Ogden, who was a lawyer in Catskill, New York.* Only partly true. Though Sybil did marry Edmond, the Ogdens didn't move to Fredericksburgh until the 1780s, according to census records and land deeds. Sybil married Edmond in 1784 when she was already twenty-three years old. A deed from 1793 referred to Edmond as a "farmer." No records of any of Edmond's records as a lawyer can be found in Catskill. *Sybil bore six children: four boys and two girls.* Unsubstantiated. No medical, birth, school, marriage or death records are available for Sybil's children. There is no mention of the names of the children or graves. *One of her children was a hero in Kansas.* False. Records of Edmund Augustus Ogden, hero of Fort Riley, Kansas, indicate that his mother was Julia Ogden, not Sybil. Sybil was, in fact, the hero's grandmother. *The family later moved to Unadilla,*

... State of Connecticut of [?] fifty two years of age do testify & say that I was a Soldier in the War of the Revolution. That on the fifteenth day of April 1776 I enlisted for twelve months into a company of I think Connecticut State Troops under the command of Albert Chapman of Fairfield Town & County & State aforesaid as Capt. in Col. Elmores Regiment and marched with said company to Albany where we joined the Regiment. The Regt then marched to Fort Stanwicks to the German flatts so called where we built a fort called Fort Dayton. We then marched to Fort Stanwicks where we relieved a Massachusetts Regiment & we continued and finished the fort by them begun & continued at said Fort under the command of said Officers untill the 18th day of April 1777 at which time the Regiment was discharged making my term of service one year & three days. I well remember Edmond Ogden then of said Town & County of Fairfield & State aforesaid enlisting with me into said company under said Capt. Chapman in said Col. Elmores Regiment & went to Albany with me & from thence to the German Flatts & from thence to Fort Stanwicks & continued there with said company the full term of One Year & three day & was discharged when I was. The said Edmond Ogden enlisted and served as Sergeant of said company the whole term aforesaid. He & I were School boys & always very intimate untill he moved into the State of New York. The reason why the company staid over the term of enlistment was in consequence of waiting for a Relief guard.

Fanton Beers

Fanton Beers's deposition letter. *Courtesy of the National Archives.*

Julia Ogden's deposition letter. *Courtesy of the National Archives.*

Rejection letter. *Courtesy of the National Archives.*

where Sybil died on February 26, 1839. Again, partly true. Though this is the date of death, there are no records of Edmond Ogden having lived in Unadilla, New York.

INVESTIGATIVE SUMMARY

Sybil Ludington Ogden has every reason to be celebrated as a national hero. Her ride rivaled that of Paul Revere's. She is most deserving of a statue by Anna Hyatt Huntington, and an eight-cent postage stamp in her honor (though close inspection will reveal a major error on the back of the stamp). The poems, songs and parades are fitting tribute to her heroic deed. So, why is she still not at rest? Why is she still fighting to be heard? Why is her spirit running loose in the Hudson River Valley?

Sybil Ludington deserves the right to be known for who she was in the world in which she lived and in all the roles she played. As a daughter, she likely traveled faithfully with her father to do chores and

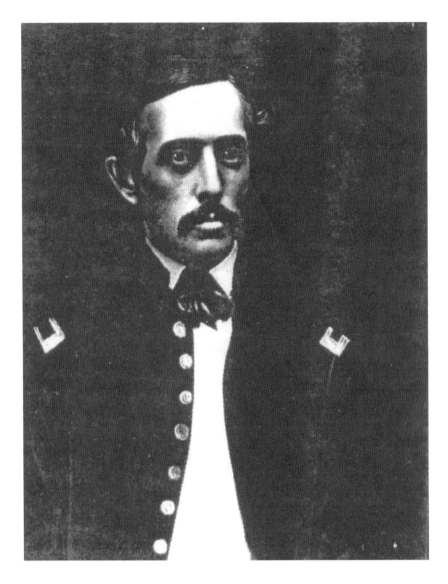

Courtesy of the Kansas Historical Society

deliver grain from her father's mill, thus learning the whereabouts of his troops leading to her act of heroism on April 26. As an aid to her mother, she helped raise nine of eleven children and remained with her mother almost down to the birth of the last child. (Sybil was married in 1784; Sophia was born in 1784; Lewis was born in 1786.)

As a wife, she helped run a farm and a possible public house and then left her home to help her husband begin a new life in Catskill. When her husband died, she took on the responsibility of raising their child. As a single mother, she raised a boy in an area devastated by yellow fever and found a way to prosper in business when few women could. Her boy became a lawyer and later a New York State assemblyman. (An accomplishment also attained by Colonel Ludington in his later years.) As a grandmother and live-in mother-in-law, she helped raise six children, one of whom graduated from West Point and became a hero in his own right.

Again, the question remains, did Sybil Ludington return after two hundred years to set the record straight? Could it be that this novice researcher suddenly became skilled enough to uncover the documents, errors and secrets hidden so well for so long? Or did Sybil's spirit guide the heart and hand of this writer?

Acknowledgements

Special thanks to my family: June, Jamie, Vinny, Christian and Cadence, for sharing my heart and my time. Thanks to Sallie Sypher for her historical editing and Peggy Burns for her help with formatting. And thanks to Saunders Robinson, Anna Kasabian, Julie Foster, Christine Langill and Doug Meyer from The History Press.

For their great assistance and aid with the investigations and compilations of each individual chapter, I'd like to thank the following:

CHAPTER I

Edward Ganbaum; Januarie Keeler; Anthony Porto Jr. and Tony Porto Sr.; Andrew Campbell; Mia Brech; Christina Mucciolo; Catherine Wargas; Allan Warnecke; Alfred and Lillian Eberhardt; Mike Troy; The Katonah Paranormal Society: Kathy Piccorelli, Brian Plog, Buddy Banks, and Karen Darby; Mike Ryan, Danielle Sheridan, Andy Middlebrook, Will Pidgeon, and Cat Pidgeon of the Dutchess Paranormal Society; Jeanette van Dorp; Vanessa Rolls; Anna Pomoryn; Kent Historical Society.

CHAPTER II

Anthony Porto Jr. and Anthony Porto Sr.; Betty Behr; Andrew Campbell; Christina Mucciolo; Catherine Wargas; Allan Warnecke; Reginald White; Dr. Sallie Sypher; Carol Bailey; Alfred and Lillian Eberhardt; The Katonah Paranormal Society: Kathy Piccorelli, Brian

Plog, Buddy Banks, Barry Pirro, and Karen Darby. The Mahopac Library Writers' Group; Kristy Farina and Mike Joyce.

CHAPTER III

Penny Osborn Tarbox; Gil Tarbox; Betty Behr; Andrew Campbell; Christina Mucciolo; Catherine Wargas; Allan Warnecke; Reginald White; Alfred and Lillian Eberhardt; Sallie Sypher; The Katonah Paranormal Society: Kathy Piccorelli, Brian Plog, Buddy Banks, and Karen Darby. The Mahopac Library Writers' Group: Michael Keropian; Jan Maline; Kathy O'Donnell; Buddy Banks; Gil and Penny Tarbox; Karen Darby; Siobhan Tripodi.

CHAPTER IV

Wray and Loni Rominger; David Hayden; Ruth and Roberta Silman; Andrew Campbell; Members of the Mahopac Library Writing Group; Richard A. Muscarella; Historians at the Putnam County Historian's Office; Edward Lanyon Woodyard; Kansas State Historical Society; Alfred and Lillian Eberhardt; technical assistants and friends at the Pelham Middle and High School.

Bibliography

CHAPTER I

"Awful Murder." *Hudson River Chronicle*, October 24, 1843.

Blake, William J. *The History of Putnam County, N.Y.* New York: Baker and Scribner, 1849.

Cheli, Guy. *Images of America: Putnam County*. Charleston, SC: Arcadia Publishing, 2004.

"Confession of George Denny Convicted of the Murder of Abraham Wanzer." *The Republican*, June 25, 1844.

Crawford, Joshua S. "Written on the Murder of Mr. Wanser Of Philipstown, Putnam County, and the Execution of George Denny." *The Putnam County Courier*, Carmel, NY, April 27, 1923.

"Criminal Court of Putnam County." *Hudson River Chronicle*, November 28, 1843.

"Execution." *Poughkeepsie Journal and Eagle*, August 6, 1844.

Jewell, Willitt C. *Putnam County in Southern New York*. Vol. II. New York: Lewis Historic Publishing Company, Inc., 1946.

Minutes of a Court of Oyer and Terminer held at the Court House in Carmel for Putnam County, May 27, 1844.

Pelletreau, William S. *History of Putnam County, New York*. Philadelphia: W.W. Preston, 1886. Reprinted. Brewster, N.Y.: Landmarks Preservation

Committee of Southeast Museum, 1975. Reprinted. Interlaken, N.Y.: Heart of the Lakes, 1988.

"The People vs. George Denny." *Poughkeepsie Journal*, September 27, 1843.

Raymond, Charles A. Historic Carmel, Mahopac, Mahopac Falls: A Bicentennial Profile

"Trial of Denny- Full Particulars." *The Republican*, June 11, 1844.

"The Trial of George Denny." *Poughkeepsie Journal*, November 22, 1843.

"Westchester Oyer and Terminer. Criminal Court of Putnam County." *Hudson River Chronical*, November 28, 1843.

CHAPTER II

Beers, J.H. *Commemorative Biographical Record of the Counties of Dutchess and Putnam Counties*. Chicago: J.H. Beers and Company, 1897.

Bromfield, Roger. "The Carmel Fire." *Patent Trader*, October 24, 1974.

Cmero, Mike, Jr. "A Reflection of the Past." *Journal News*, November 5, 1995.

"Glimpse of the Past." *Putnam County Trader*, April 18, 1996.

Tomcho, Sandy. "Terror Tour." *Times Herald-Record*, October 29, 2002.

Zimmerman, Linda. Ghost Investigator: Volume 3. A Spirited Books Publication. 2003.

Deeds: Putnam County Clerk's Office
Liber 111 pg. 551 May 25, 1916
Liber 130 pg. 215 June 29, 1923
Liber 189 pg. 148 Sept. 19, 1933
Liber 261 pg 35 Oct. 9, 1941
Liber 263 pg 281 Oct 11, 1941
Liber 358 pg 315 January 8, 1949

Liber 484 pg 327 January 10, 1957
Liber 668 pg. 1178 July 7, 1968
Liber 777 pg. 944 June 12, 1981

CHAPTER III

Anik, Adam. "Out With the Old, In With The New (Mt. Ninham Tower)." *Putnam County News*, October 28, 1998.

Beers, J.H. *Commemorative Biographical Record of the Counties of Dutchess and Putnam Counties*. Chicago: J.H. Beers and Company, 1897.

Frazier, Patrick. *The Mohicans of Stockbridge*. Lincoln: University of Nebraska Press, 1992.

Golding, Bruce. "Refurbished fire tower's views dazzle residents." *The Journal News*, May 2005.

Greenwood, Lynn E., Sr. "Daniel Nimham, king of Wappinoes, was 'worthy veteran.'" *The Reporter Dispatch*, March 22, 1996.

Gross, Eric. "DEC criticized for inaction on emergency radio tower." *Putnam County Courier*, July 27, 2000.

Grumet, Robert S. "The Nimhams of the Colonial Hudson Valley, 1667–1783." *Hudson Valley Regional Review*, no. 9 (September 1992).

"Honoring Native Americans." *The Reporter Dispatch*, September 29, 1996.

Khasru, B.Z. "Monument planned for Indian Chief." *The Reporter Dispatch*, January 24, 1994.

Matthews, Cara. "Donations sought for Chief Nimham." *The Journal News*, June 20, 2005.

Muscarella, Richard. "Memorial planned for Chief Nimham." *The Putnam Courier-Trader*, January 20, 1994.

"Ninham, Lands Lost While fighting French, Gave His Life for Colonists' Cause." June 9, 1938.

Pelletreau, William S. *History of Putnam County, New York*. Philadelphia: W.W. Preston, 1886. Reprinted. Brewster, N.Y.: Landmarks Preservation Committee of Southeast Museum, 1975. Reprinted. Interlaken, N.Y.: Heart of the Lakes, 1988.

"Putnam County Birthday Celebration And Chief Ninham Memorial Dedication." *The Putnam Courier-Trader*, June 5, 1996.

Risinit, Michael. "Kent fire tower offers grand view." *The Journal News*, May 9, 2005.

————. "Sculptor looks to history to create Nimham statue." *The Journal News*, July 9, 2005.

"Two hundred Attend Ninham Dedication." *Putnam County Republican*, June 1, 1938.

Vaughn, Marlon. "Stone dedicated to honor American Indian legend." *Reporter Dispatch*, June 16, 1996.

CHAPTER IV

Berry, Eric. *Sybil Ludington's Ride*. New York: Viking Press, 1952.

Braley, Berton. "Sybil Ludington's Ride." *The Sunday Star: This Week's Magazine* (Washington, D.C.), April 14, 1940.

Case, James R. *Tryon's Raid*. Privately printed, Danbury, CT, 1927. (Published on the occasion of the 150th Anniversary)

Curan, John. *The Attack at Peekskill by the British In 1777*. New York: Office of Peekskill Historian at the Peekskill Museum, 1998.

Ephlin, Donald L. "The Girl Who Outrode Paul Revere." *Coronet*, November 1949.

"Five Historic Roadside Markers Dedicated by DAR Monday." *The Putnam County Courier* (Carmel, NY), May 17, 1935.

Foley, Janet Wethy. *Early Settlers of New York State: Their Ancestors and Descendents*. Baltimore: Geneological Publishing Co. 1993.Originally published serially. Vol. 1, 1934; Vol. 9, 1942. Reprinted in two volumes.

Grant, Anne. *Danbury's Burning*. New York: Henry C. Walck, Inc., 1976.

Heads of Family at First Census of the United of America Taken in the Year 1790. New York Heritage Series. Number I. Washington, D.C.: Government Printing Office, 1908.

Jacobus, Donald Lines. *History of and Genealogy of the Families of Old Fairfield*. Vol. 1; Vol. 2, Part 1; Vol. 2, Part 2; Vol. 3; 1932.

Johnson, Willis Fletcher. *Colonel Henry Ludington: A Memoir*. Privately printed: New York, 1907. Published by his grandchildren, Lavinia Elizabeth and Charles Henry Ludington.

Patrick, Lewis S. "Secret Service of the American Revolution." *The Connecticut Magazine* 11, no. 2, 1907.

Pension Application Files: "Edmond Ogden #R777." U.S. War Department. September 8, 1838.

Smith, Mabel Parker. "Unsung Heroine of Revolution Became Inn-Keeper On Busy Main Street Corner in Early Catskill." *The Daily Mail* (Catskill, NY), article in four parts, January 9–12, 1978.

About the Author

Vincent T. Dacquino is the author of several books for young children, including the popular young adult novel Kiss the Candy Days Good-Bye, a Dell/ Yearling paperback. He is the founder of the Peanut Butter and Jelly Writing Academy and has made numerous appearances at schools and historical sites based on his adult biography, Sybil Ludington: The Call to Arms. A "classroom-ready version" of this book for fourth- and fifth-grade students was released in May 2008 by Purple Mountain Press.

Dacquino most recently addressed teachers at the October 17, 2008 New York State Historical Association October Conference for Teachers at Cooperstown, New York. He has addressed English teachers at annual conferences at the county, state and national levels. He has presented at BOCES Young Adult conferences for over twenty-five years. Dacquino was a teacher in Westchester County for over thirty years and is recently retired as the director of the BEPT Teacher Center, serving the Pelham, Eastchester and Tuckahoe School Districts. He retired from teaching in 2007 to dedicate more time to his writing and lecturing. He resides with his wife, June, in Mahopac, New York.

Please visit us at
www.historypress.net